What is Art?

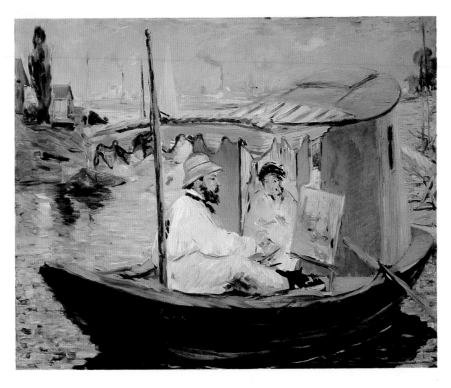

Rosemary Davidson

OXFORD UNIVERSITY PRESS

Acknowledgements

I acknowledge with pleasure and gratitude a debt to many mentors and friends, dead and alive, who have in their different ways opened my eyes and mind to art:

Martha Steinitz, who on Saturday mornings in Leeds revealed a world of European visual and musical culture to the unknowing schoolgirl that I was. **Louis Porter**, who was the first person I knew who bought, hung, and talked about contemporary art.
Alan Davidson, my brother, whose passion for Sienese paintings sent me to Italy with a guidebook specially written for me by him.
Janet Ward, who bravely shared the discovery of Italian art from the back of a motor scooter. **Lynda Grier**, whose early patronage of Stanley Spencer taught me to follow my artistic hunch.
Kurt Rowland, who showed me a way of looking that embraced the whole of our visual environment. **Jeannine and Reg Alton**, who, from when I was a student to the present day, have always leavened my ignorance and broadened my appreciation of art. And finally to all the artists who have contributed their works to my gallery and informally taught me much about the creative process.

On a practical level I should like to thank **Jo and Ken Brooks** for criticism and help, particularly with Chapter 11; **Katherine James** for patient checking and correcting; and **Barbara Brenchley** for comment and help with the Glossary.

Oxford University Press, Walton Street, Oxford OX2 6DP
Oxford New York Toronto
Delhi Bombay Calcutta Madras Karachi Petaling Jaya Singapore
Hong Kong Tokyo Nairobi Dar es Salam
Cape Town Melbourne Auckland
and associated companies in
Berlin Ibadan

Oxford is a trade mark of Oxford University Press

A CIP catalogue record of this book is available from the British Library
ISBN 0-19-910042-X

This is a Mirabel Book which was designed and produced by
Cynthia Parzych Publishing Inc.,
648 Broadway, New York, NY 10012

Designed by Malcolm Smythe/Camel Corps

Edited by Katherine James

Printed and bound in Spain by Fournier A. Graficas, S.A.

Contents

1 Looking and seeing

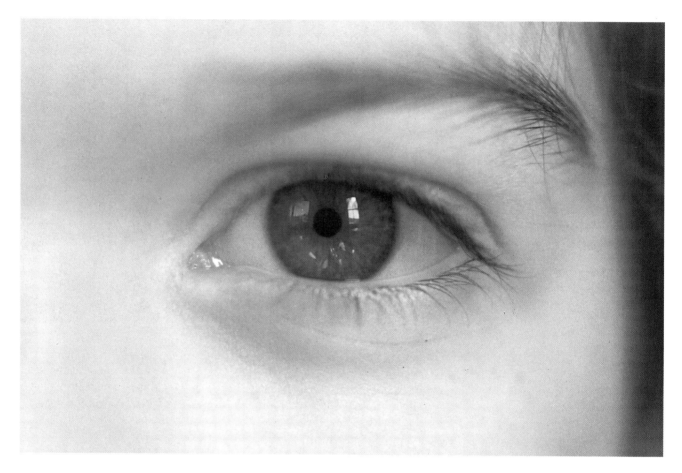

IF YOU THINK LOOKING IS THE SAME AS SEEING – YOU'RE WRONG!

We've all got the same apparatus for looking: *eyes*. But what you see and what I see, when we are looking at the same person or thing or place, may be very different. It all depends on what your brain does with the images that you take in through your eyes. And that depends on who you are:

- how old you are

- where you live

- how you've been brought up

- what you've already seen

- what you expect to see

- what you're interested in

It's as if we are all wearing different kinds of glasses that make us see things differently.

Experiment time

What's this? Right. It's part of a bicycle wheel. But you only know that it's part of a bicycle wheel because you already know what the whole of a bicycle looks like. If you'd never seen a bicycle in your life, you wouldn't know what it was.

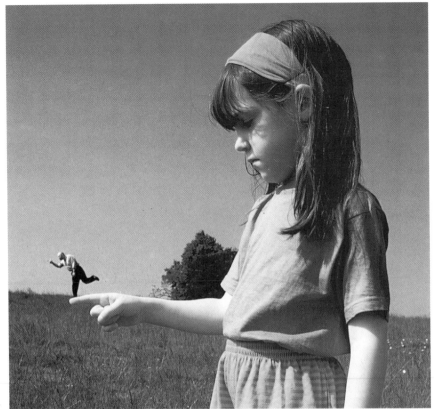

What about this? What do you see? Do you see a little man dancing on the girl's finger? If you believe in gnomes and fairies perhaps that's what you do see. But if you don't, you look again, this time harder, and perhaps you see the little man dancing along in the distance and the girl standing quite close to us, holding out her finger. You realize there's a big space between them. You've been able to use a number of clues to work this out. You can see that the girl is in a field stretching away from you (you can tell this by the way the blades of grass get smaller). So the man may be dancing along the *far* side of the field.

You can only use clues like these if you have looked at pictures before.

What do these black dots make you think of?

Maybe they look like eyes to you? Or heads? Or could they be parts of flowers, or an animal's ears? You can probably think of lots of other things they might be. The point is that your brain is always trying to make a connection between shapes you see and things you already know about.

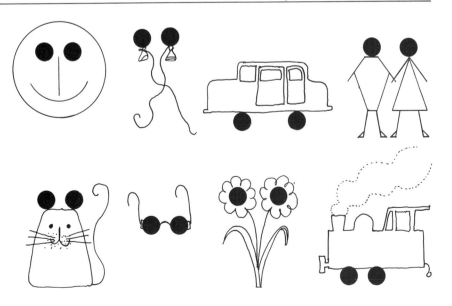

Stare at this ink blot
for a while.
What do you see?
A man?
A bird?
Something else?

What you see depends on *you*.
But it's interesting to know that
when people look at vague shapes
they very often see faces or people.

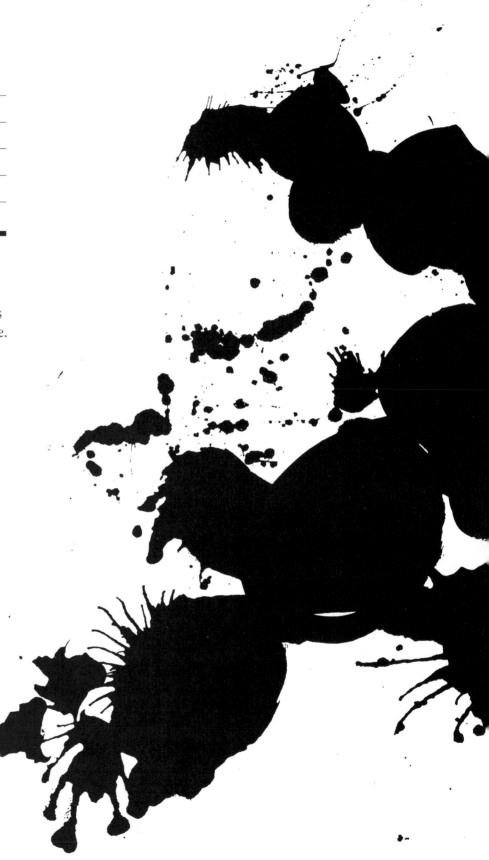

What has all this got to do with art? Quite a lot. Artists don't need to spell everything out, to show every detail. They can rely on us to do half the work! One of an artist's skills is knowing what *our* brains are going to do with the marks *they* have made. Artists have to be able to guess what we will see when we look at what they have done. But they can only do this up to a certain point. You and I are different, so we are bound to see the same picture differently – we even see colours differently.

Children's Water Dreaming with Possum Story

WHAT YOU SEE DEPENDS ON WHO YOU ARE

Here's a simple example. What is this? Probably most people reading this book will say it's a goat. But when this drawing was shown to some children in Kenya in Africa none of them said it was a goat. They have goats in their village and they know perfectly well what they look like. But all *their* goats have tails turning *upwards* – so they knew it couldn't possibly be a goat.

Here's a more complicated example. When you look at this picture you may see patterns rather like necklaces, or maybe you see hamburgers or mouths . . . But an Australian Aborigine would know that it was to do with a rain-making ritual that Aborigines have taken part in for thousands of years. An Aborigine would see water cascading from one water-hole to the next, and the tracks of a boy and a possum out looking for food. He or she would be looking at the picture as if looking down from the air.

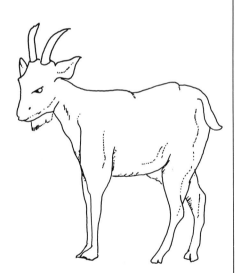

This picture, called *Children's Water Dreaming with Possum Story*, was painted in acrylic paint on a piece of hardboard by an Australian Aborigine called Old Mick Tjakamara. Acrylic paint and hardboard are modern, but the ideas in the picture are ancient.

Mick Tjakamara, 'Children's Water Dreaming with Possum Story', 1973, poster paint and PVA (house paint) on board, 45 x 58 cm.

What You See Depends on What You *Expect* to See

Take a look at this drawing.

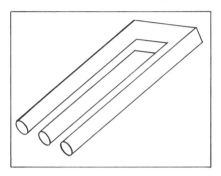

Even if you didn't know it was a tuning fork, you'd soon see that there was something wrong with it. It's an impossible object. Try to work out why. Your brain keeps wanting to turn it into a proper tuning fork, one that you can recognize, because that's what you expect to see.

Take a quick look at this sign and read it out loud.

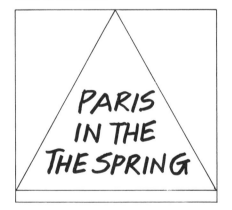

Now take a more careful look and read it out again. At first you probably read what you expected to find. Then you read what was really there.

What do you think when you look at this painting by René Magritte? Do you first see feet, then boots, or the other way round? You're puzzled, because what you're looking at doesn't fit in to anything you know.

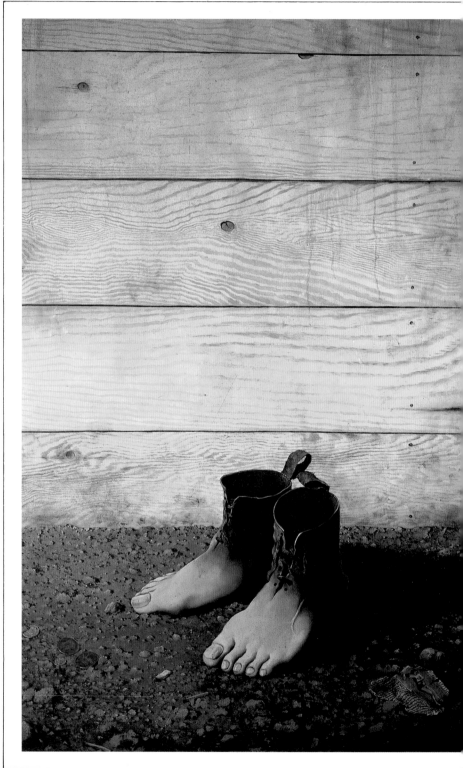

YOU SEE WHAT INTERESTS YOU.

There's a special kind of camera that can photograph the way the eyes move when they're looking at a picture. It makes a map of the eye movements. From this map you can see how your eyes have moved round the picture and which parts of it you've been looking at most. These are the parts that have interested you most.

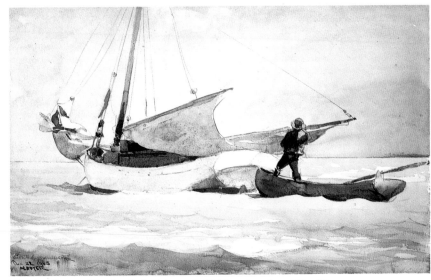

'Winslow Homer, 'Stowing Sail. Bahamas', 1908, watercolour, 35 x 55 cm.

This is a painting called *Stowing Sail. Bahamas*, by the American artist Winslow Homer. From the map of the eye movements below you can see how the eyes of the person looking at the painting kept moving between the two boats. But most lines are over the man on the right, because the viewer's eyes kept coming back to that man.

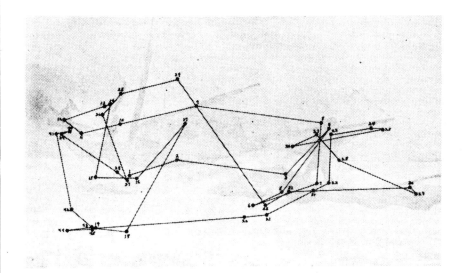

Magritte's Magic

René Magritte lived nearly all his life (1898–1967) in Belgium. He liked to paint the ordinary objects of his everyday life—loaves of bread, boots, his pipe, and his bowler hat—in such an odd way that they give you a shock and make you look again. Did you do a double-take when you looked at *Le Modèle Rouge*, left?

"When I was a child," Magritte said, "a little girl and I used to play in the old cemetery . . . where an artist from the city would be painting in a picturesque walk with broken stone columns scattered among the dead leaves. It seemed to me that the art of painting was vaguely magical."

René Magritte, 'Le Modèle Rouge', 1935, oil on board, 56 x 46 cm.

YOU SEE
WHAT THE ARTIST
WANTS YOU
TO SEE

But what we see and how we look at a picture does not only depend on who we are, what we expect to see, and what we're interested in. There's something else that's very important. And that's the way the artist builds up the picture, composes it with shapes and colours. A skilled artist can make us look at a particular part first, and can make our eyes move around in a certain direction.

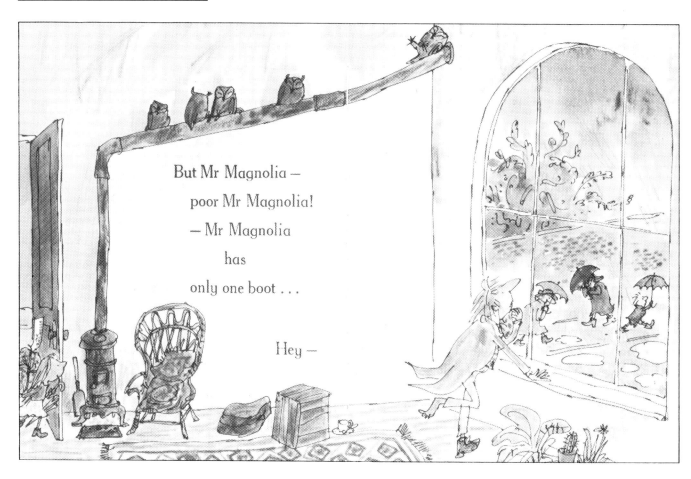

But Mr Magnolia —

poor Mr Magnolia!

— Mr Magnolia

has

only one boot . . .

Hey —

This is a picture by Quentin Blake from his story for children, *Mr Magnolia*. Our eyes naturally begin to look at a picture somewhere over on the left. But this time we start looking over on the right, where Mr Magnolia is standing by the window, as there's so much going on in that part of the picture. This is just what Quentin Blake wants to happen, because it is important to the story that we don't notice the little girl coming in until *after* we've looked at Mr Magnolia. Probably the artist didn't work this out in detail — he did it by instinct.

2 What's art for?

If somebody asked you, 'What's food for?' or, 'What are houses for?' you'd find it easy to answer. But the question 'What's art for?' isn't such an easy one to answer.

When you set out to make a drawing or a painting for yourself, you're not usually thinking about 'making art', but about doing something *for a reason*. You may want to record something that has happened – like a volcano blowing up. Or you might want to illustrate a story you've read, or one you've written yourself. You may want to have a go at making a picture of your friend, or of your cat. You might want to do something quite different, like designing a poster, or making a necklace. Or you might just want to settle down with paper, colours, and a pair of scissors and have fun with them. Whatever you do, there'll be a *secret ingredient*. That is the bit of yourself you put into whatever you're doing. We all do things in our own way, choosing this colour and not that, this shape and not another. You could call it a kind of language that is our own.

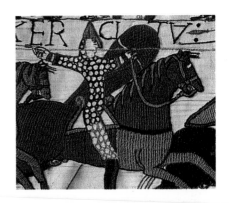

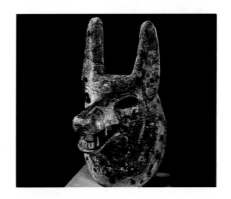

These are just the sort of things that artists do. In the past they were often doing a job, employed by a rich person, by a ruler, or the Church. They might have been painting a wall in a church or palace, illustrating a legend, or setting down the scene of a battle. They could have been painting a series of pictures to go over an altar, or making tiny, rich, detailed pictures (illuminations) to illustrate religious books.
Like you, they could have been doing things just for fun – like the people who made the gargoyles high up on the roofs of cathedrals. They, too, were using their own 'language'. After a while, you come to recognize the work of an artist by his or her 'language'. We call it 'style'.

In the next few pages you can see examples of the important ways in which people have made art. (The pictures on this page are from chapters in this book that show the different reasons why people make art.) So if someone puts the question, 'What's art for?' you'll have some idea how you might want to answer it.

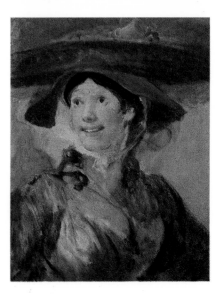

Art is for telling a story

The stories that artists tell are about all sorts of things – stories from the different religions of the world, from the legends of the Ancient Greeks, from India, China, and the Native American Indians. They also tell stories from the 20th century.

One of the best known modern storyteller-artists is N. C. Wyeth (1882–1944). His son Andrew, also an artist, tape recorded some of his memories of his father and described the way he worked. This is what he said about the painting on this page:

'He painted it in one morning. At that time he was doing pictures of adventure stories and he could make up any subject he wanted as long as it had to do with the West and was something with a lot of drama. He was getting us kids breakfast early and got the idea of this train robbery, went up to the studio, and just painted it like mad. It was finished by noon.'

N. C. Wyeth was very skilled at knowing what to concentrate on and what to leave out. He painted only a small part of the train, just enough for us to recognize it as a train. He concentrates everything on the figure of the robber, whose flying collar and foot stepping forward make us feel he is still moving. All you see of the passengers is a glimpse of a frightened face and two desperate, raised hands. Everything else is left vague – the second robber clambering up holding a knife in his mouth, the landscape, the steamy foreground.

Wyeth liked illustrating what he called 'a good yarn': *Treasure Island, Robin Hood,* and *The Three Musketeers* were all stories that he illustrated. He also liked to do paintings of dramatic stories he just imagined, especially about the Wild West.

He liked to learn about things at first hand. To learn about the North American Indians, he went to stay with the Navajo people for a while. To get to know the cowboy way of life, he worked on a ranch in Colorado rounding up cattle.

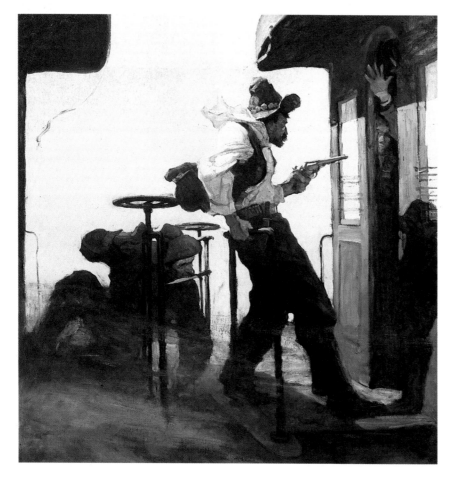

N. C. Wyeth, 'McKeon's Graft (Train Robbery)', 1912, oil on canvas, 112 x 84 cm.

Art is for making pictures of people

People are interested in people. So portraits are a form of art that people take to with enthusiasm – both painting them and looking at them. Also, they have been, and still are, a good way for artists to earn their living.

This portrait is of Ranuccio Farnese and we know that it was painted in 1542. He was then 12 years old, studying Classics at the Italian University of Padua. He was already Prior of an important institution in Venice, and at 15 he was made a Cardinal of the Church, an even more important position. Knowing about his life, you start to notice things about the picture. His clothes are very grand for a boy. But his face looks very young, he seems rather shy, and his ears stick out.

The artist who painted the portrait was Titian (about 1485–1576). He painted people of all ages. He was particularly good at painting children and young people. We know that he painted Ranuccio partly from life and partly from memory. Surely he must have painted the face while the boy was there in front of him.

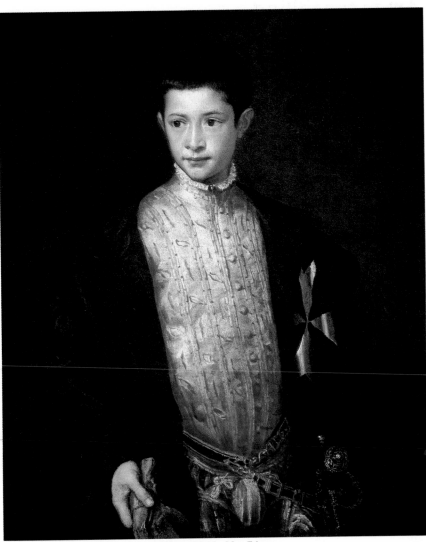

Titian, 'Ranuccio Farnese', oil on canvas, 1542, 89 x 74 cm.

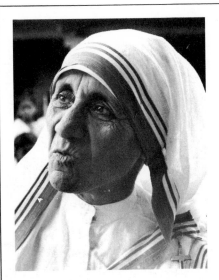

A photograph portrait

Photograph portraits have almost taken over from painted portraits in the 20th century – to show likenesses of people. A photographer can show a person's character very clearly by choosing a particular angle, by arranging the light in a certain way, and by catching a particular expression on the person's face. This photograph is of one of the best-known faces in the world. It is Mother Teresa of Calcutta.

Art is for recording a scene

The scenes that artists have recorded go from battles to picnics, from murders to miracles. When a scene appeals to an artist's imagination, because it is interesting to him in a particular way, because it helps him to do the things that are interesting *him*, then we are likely to get a good picture.

Georges Seurat (1859–1891) found the scene he wanted by the River Seine. There was an island, *'la Grande Jatte'*, where people went to enjoy themselves on Sunday. The light was special,

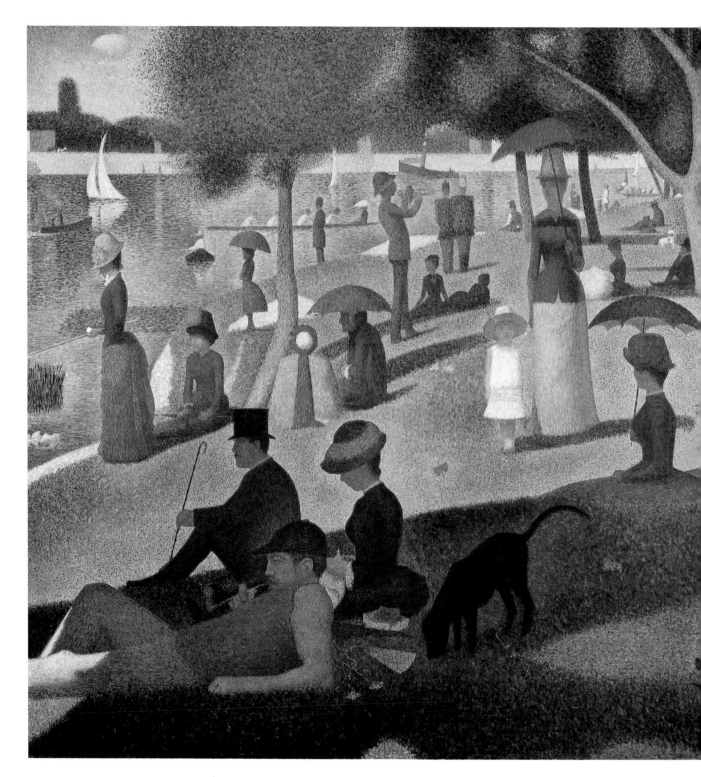

reflected from the river. There were people walking, sitting, lying down, fishing, playing the trumpet. There were trees, children, boats, parasols, dogs, even a monkey. So there were lots of different shapes and colours to play around with. Seurat made hundreds of small drawings and paintings of the people and animals he saw. Then he experimented with different ways of putting them together. A picture like this is a combination of things seen, remembered, and imagined.

If you look closely, you'll see that for most of the picture he put the paint on in little dots of different colours. Seurat was very interested in colours and how they worked together. He thought colours worked better if you put them next to each other in dots than if you mixed them together. This is one of the first paintings to be done in that way, using 'pointillisme' (*pointe* = French for 'point' or 'dot'). Take a good look at the detail below.

This is the kind of picture that leads your eye round from one mini-scene to another, from one character to another. You want to make up stories about the people. In fact someone did. James Lapine and Stephen Sondheim wrote a musical based on this picture called *Sunday in the Park with George*. The painting comes to life on the stage – the characters 'form' the painting. At the end of each act all the characters together sing:

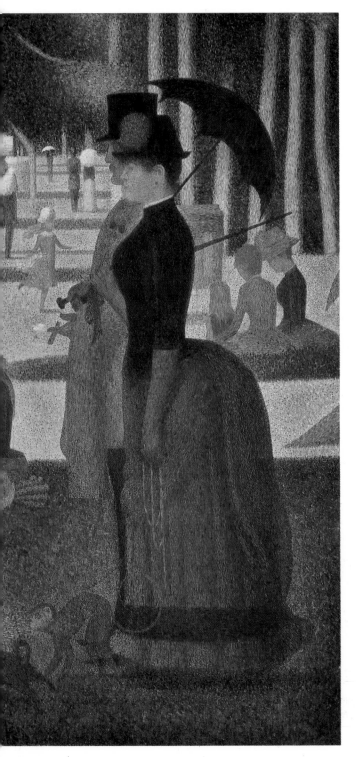

> '*Sunday*
> *By the blue*
> *Purple yellow red water*
> *On the green*
> *Orange violet mass*
> *Of the grass*
> *In our perfect park . . .*'

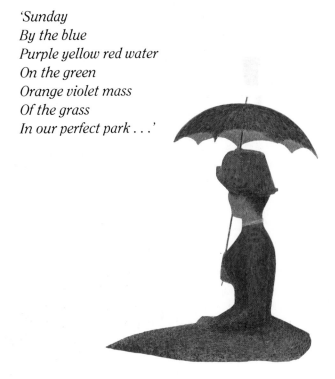

Georges Seurat, 'A Sunday Afternoon on the la Grande Jatte', 1884–1886, oil on canvas, 208 x 308 cm. Seurat died when he was only 31.

17

Art is for fun

When you were very young, you probably spent time messing around with paper and paints, sand and playdough. You were experimenting, finding out what happened when you handled these materials, – and enjoying yourself. You may think that artists always know what they're doing, that they've already learned how to do things. But in fact the greatest artists keep on experimenting and learning. Often the way they do this is by playing around with materials.

Some artists let us see the way they do this. One of these was Paul Klee (1879–1940). He came from Switzerland and was one of the most playful and humorous artists of this century. His son Felix tells us that he produced about 10,000 paintings and drawings!

Klee called this picture *Tomcat's Turf* (meaning his territory). His tomcat roamed over a landscape that included a moored boat, a watermill, a red sun, green fields – and a mouse. Klee liked to cut up his pictures and re-arrange the parts. In *Tomcat's Turf* he switched the upper and lower parts round, so that now the mouse, high up in the green fields, appears to be lording it over the cat, down below in the blue sky. Perhaps the big letter F is for Fritzi, the name of his cat. What could the B be for? Bern, the town where Klee lived? A town mouse from Bern on holiday in the country?

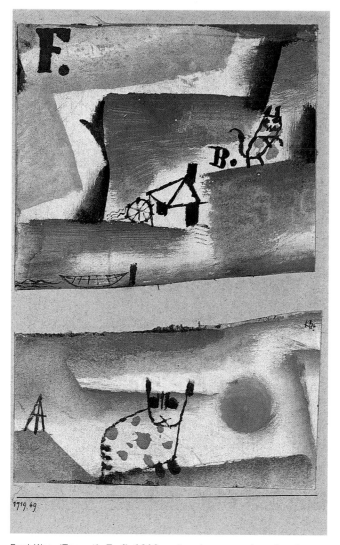

Paul Klee, 'Tomcat's Turf', 1919, watercolour, gouache, oil and gesso on two sections of cloth, 13 x 14 cm (upper section), 9 x 14 cm (lower section).

Klee at home

If you think that the reason Klee was able to produce so much was that he had a devoted wife in the background who protected him from all interruptions, you're quite wrong. When Felix was small, it was his father who stayed at home, looked after him, and did the cooking. Klee painted his pictures in the kitchen, stirring the soup with the end of his paintbrush! He loved animals, particularly cats. He kept them,

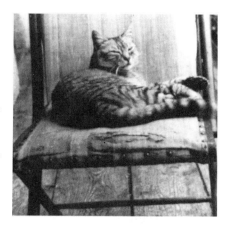

photographed them, wrote about them, and once even signed a letter with his tomcat Fritzi's paw! He used cats and other animals in his pictures. This is a photograph of Fritzi in 1921.

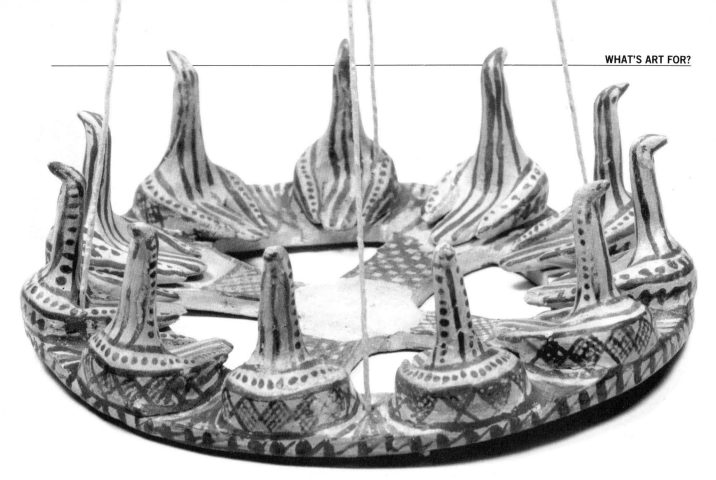

Art is for magic

People have made images for use in magic as far back as history goes – back at least to the paintings our ancestors made in caves 15,000 years ago. The objects used for magic are sometimes rather mysterious to us – we don't really know in what way they were used.

This wheel is one of those. It was found in Greece and is about 2,700 years old. Nobody has ever found another one, but there are pictures of wheels like it on Greek vases. It is made of terracotta and the striped birds are wrynecks (a kind of woodpecker). The wheel is only 28 cm across. The holes for strings show that it must have been meant to be hung, like a mobile, or to be swung round. Some people think that it is connected with the idea that a girl could find her lost lover by spinning a wheel. Whatever it was used for, we do know that among many peoples circles are sacred.

Magic circles

Scattered round the world are mysterious stone circles of great age. In Britain the best known is Stonehenge, in the south of England. It is 30 metres across, and built of stone. It too is a mystery, but people think it was built about 4,000 years ago for religious ceremonies to do with the sun.

The Native Americans of the Southwest also made sacred circles, called 'medicine wheels'. They were used in Native American 'medicine' (magic).

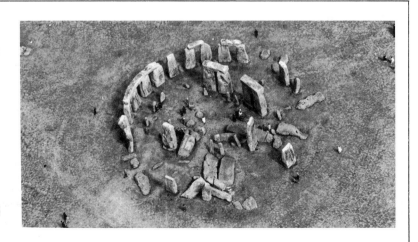

Art is for decoration

Most of us want to make our mark on our surroundings. We may decorate our bodies. We may arrange things in a pattern. We may weave cloth using a variety of patterns – for clothes, wall hangings, or rugs. We may make everyday things, such as pots, glasses, and knives, in beautiful shapes and decorate them.

What you do with your surroundings and your personal possessions depends on who you are, where you are, and what kind of life you lead. You may decorate your room with posters, or your pencil case with stickers. This isn't art. But it *is* something to do with our wish to make things around us more interesting or more beautiful than they need be for practical purposes, and to make them 'special' to us.

If you were a Japanese person in the 18th century, one of your special personal possessions might have been a netsuke (pronounced 'netsooki'). At that time the Japanese wore kimonos, without pockets. So how did they carry their money, their tobacco pipes, and their writing implements? They put them in little pouches or cases and hung them by cords from their sash or belt. And they fastened the cords with a netsuke, which is a small toggle usually carved out of wood or ivory. This drawing, by Tori Kiyonaga (1752–1815), shows a man wearing a netsuke in the form of an octopus, for holding his tobacco pouch.

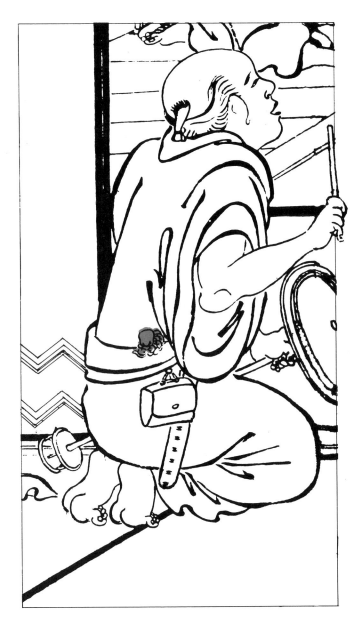

Netsuke toggles

Netsuke were like miniature sculptures, very often in the form of an animal. They had to be very smooth, with no sharp ears or claws or tail that might catch on the kimono. And, of course, they became even smoother with use. Some of the netsuke carvers were famous and signed their work, just as painters and sculptors do. There are still artists carving netsuke in Japan today, and there's even one

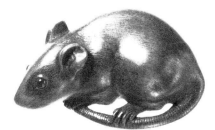

artist in the North of England making them.

This netsuke, in the form of a rat, is the same size as in the photograph. It was carved out of ivory by the Japanese artist Masanao of Kyoto, who was making netsuke between 1781 and 1800.

Netsuke were also sometimes made out of nuts, gourds or metal, as well as wood or ivory. They were luxuries for rich merchants.

3 Magic and making things happen

We don't really know how or when people began to make images.
But we do know that the oldest images we have found are to do with
people's religions and beliefs.

Cave paintings of animals

About 15,000 to 17,000 years ago, in what is now Spain and France,
people drew and painted animals on the walls of underground caves.
Many of these animals were the ones that they hunted for food – bison,
bulls, cows, deer. Some people think that these paintings of animals
illustrated the legends of the tribes that made them. Other people think
that they made these pictures to help in their hunting, so that they'd be
more likely to catch their prey – a kind of hunting magic. Either way,
the caves where they were found were not the places where these people
lived (we know this because no remains of food were found there). They
were sacred places.

This galloping horse is in the caves at Lascaux in southwest France.

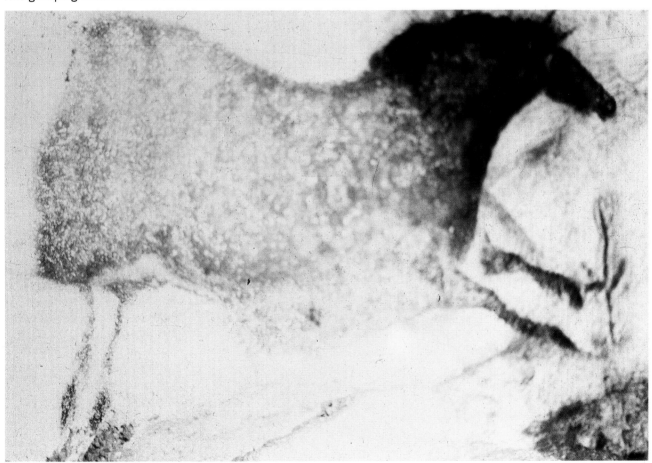

People in many different parts of the world have believed in this kind of hunting magic, for example the Bushmen of Southern Africa and the Aborigines of Australia. Rock paintings of animals on rock faces have been found in caves not only in France and Spain but also in North America, Africa, and Australia.

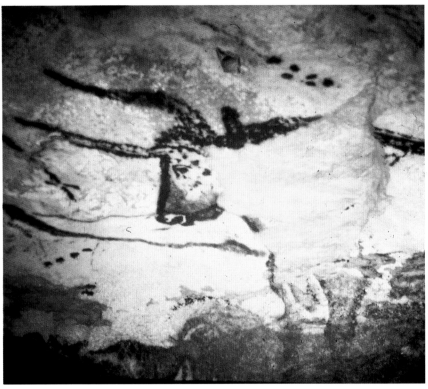

This bull with long horns is in the Great Hall of the Bulls at Lascaux. It is surrounded by painted arrows. They could be part of the hunting magic.

Is what you see the same as what you know?

The people who made these cave pictures showed them sideways on. But sometimes they added a bit. If you look at a deer sideways on, you see only one lot of antlers (because those on the other side of the head are hidden behind the first lot). But these cave painters knew that the deer really had a second lot of antlers, so they showed them too. Children often do that in their drawings. Many famous artists in the 20th century have done it too. It's rather a good idea, when you come to think of it.

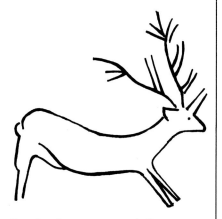

Drawing from a cave painting.

Children who made great cave discoveries

It's not just adults who make important discoveries. It was a small girl who first saw the bulls painted on the roof of the cave at Altamira in Spain which her father was exploring. Her father hadn't thought of looking up! That was in 1879.

More than 60 years later, in 1940, four boys were out for a walk with their dog at Lascaux, in the Périgord region of France. When their dog disappeared down a crack in the rocks, they climbed down to rescue him and found themselves in a great underground gallery. By the light of matches they could see that the cave walls were covered with extraordinary paintings of animals. They found their dog and went home. They kept their discovery secret until they had been down again and explored with a lamp. Only after this second visit did they tell their teacher. Then everyone wanted to come and see – the people who lived nearby, journalists, and photographers. The boys camped just outside to protect 'their' cave.

Altamira and Lascaux are two of the most famous places in the world for cave paintings. But you can't visit the Lascaux caves any longer, because people's breath damages the paintings.

Using magic

We may think it's only other people in other countries at other times who use objects for magic. But think for a moment! You probably know someone who wears a lucky charm round their neck. Charms are pretty things but they are also meant to bring good luck. You may have seen a St Christopher medal (below left) in a car. St Christopher is the Christian saint of travellers (although he's not an 'official' saint any more), and is supposed to protect them on journeys. Skiers used to carry an Ullr medal (below right) to protect them from breaking their neck or a leg. Ull, Ullr, or Uller, was an ancient Nordic nature god who is always shown wearing skis and with a bow and arrow. He has become mixed up in people's minds with St Ulrich, a 10th-century Bishop of Augsburg, who is said to give protection against natural catastrophes and dangerous journeys.

The Ancient Egyptians thought a scarab (a kind of beetle) was particularly lucky and made copies of them in large numbers out of glass or stone for people to keep. People still use them as lucky charms today. Some people even carry a special pebble in their pocket, which they can secretly touch and turn over to bring them luck. Perhaps even today we believe in magic more than we think we do.

These superstitions are 'leftovers' from deeper beliefs that people held in the past, but which have now lost their power. They are very different from the 'serious' magic of the sorcerers, magicians, medicine men, or shamans in primitive societies who, people believed, performed magic – for good or evil. They didn't work directly on the person concerned, but on an image of that person (a doll, for example), or on something to do with the person – hair, or a piece of clothing. They may have tried to cure a person of an illness, or tried to do harm. Many of the objects connected with these activities – masks, carved figures, sticks and boards – are made with great skill, and beautifully decorated.

This is a rattle, not for a baby but for a shaman (a kind of medicine man). It's made by a Native American Indian out of wood and carved with a bear's head and claws. It is for frightening bad spirits away. It comes from the Northwest Coast of America.

The evil eye

Perhaps you've read in a fairy story about 'casting the evil eye' on someone. People believed that witches and sorcerers could do this. You could protect yourself against the evil eye by wearing a little hand made of metal (North Africa), or clothes with little mirrors sewn into them (India).

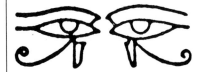

To protect themselves from the evil eye, the Ancients Egyptians used *udjatti*, which means 'two eyes'. One eye represented the Sun and the other the Moon.

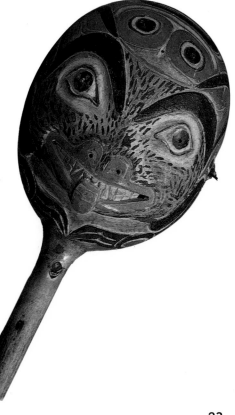

A dead man's luggage

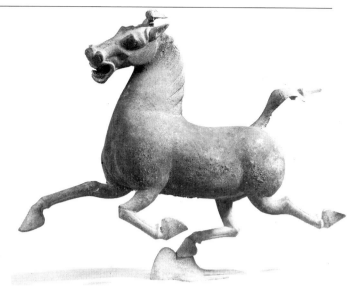

Many people believe that when you die you go on to another life. The Ancient Egyptians, for example, believed that when people died their spirit, their 'ka', left the body but would return. They thought they'd go on needing the same kinds of things they needed in this life. So they supplied their dead with 'survival kits' for the next life – pots, tools, games, musical instruments, food, and drink.

With kings, queens, and nobles they also buried fine furniture and clothes, jewellery, and even models of workman and servants to look after them. They prepared the body of the dead person so that it would not go bad and would be ready for the spirit to return to it. They embalmed it with spices and wrapped it up in bandages to make a mummy. (The Ancient Egyptians also made mummies of cats, birds, and fish, as they were sacred animals.) Because they wanted to honour a dead king or queen, the objects they made to put in the tomb were very rich and beautiful. By doing all this the Ancient Egyptians thought they could make sure that all would be well with the dead person in the future life.

In Ancient China 3,000 years ago they did the same kind of thing. A person's wealth was measured by the number of horses and chariots he had. In 1969, archaeologists dug up a tomb containing hundreds of bronze horses and chariots – so they knew it must be the tomb of an important person. They soon discovered who he was: the name of Governor Chang was written on several of the figures. Above is one of the horses from Governor Chang's tomb. It has been called 'the flying horse', as it is so much up in the air and looks as if it is moving at speed. The way a horse's legs move when it is galloping is quite complicated and many artists have got it wrong. This artist has got it nearly right. The hoof that is touching the ground is resting on a swallow. No wonder the horse is neighing with surprise!

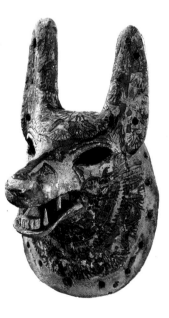

This painted wooden head is of Anubis, the Egyptian god of embalming. He has a man's body and a jackal's head. His task was to watch over the dead person and the tomb. The mask is about 2,300 years old.

What do *you* think?

What we discover in tombs can tell us a lot about people who lived long ago and what they believed in. We show mummies in museums. But some people believe that by digging up tombs we are disturbing the dead. Recently the Maoris in New Zealand asked for the return of the skulls of their ancestors which were in museums.

What do *you* think? Is it all worth it because of what we learn? Or should we respect the dead and leave well alone?

Images of gods and spirits

People of many different religions or beliefs have made images of their god or gods, or of the spirits that were important to them. Often these were the spirits of their ancestors – their grandparents, great-grandparents, great-great-grandparents, and so on. Sometimes these images helped people to worship and think about their gods. But sometimes people worshipped the image itself. They prayed to the image to make things happen. They might pray to their god of war to make them win a battle, or to a fertility god to help them have a child. In some religions (the Jewish and Muslim religions, for instance) it is forbidden to make images of God.

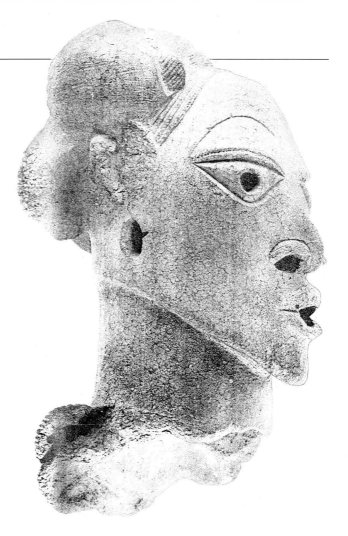

▼ The work of the modern Zimbabwean sculptor, Joseph Ndandarika (1940–1991), links up with the ancient traditions of African art. In it we see humans as part of the wider world of nature, and linked to their ancestral spirits. *Sitting King*, which is carved out of very hard stone, is one of the last works by Ndandarika. The carving was washed with boiling water by his nephew, and then waxed and polished.

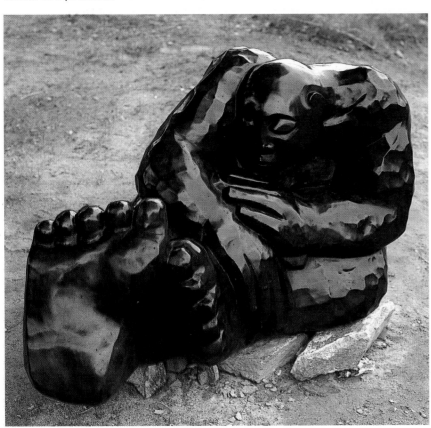

▲ This terracotta head may have been used for ancestor worship, or may have been put in a man's tomb about 2,300 years ago in the Nok Valley in Nigeria. It was discovered by a tin miner in 1954. Other male heads like this have been found in the same region by miners, and once by some schoolboys making a hockey field. They are usually the same size as real heads (this one is 35 cm high) or a little smaller. They have beautifully modelled eyes, noses and mouths, and often very complicated hair styles. Sometimes the heads are attached to much smaller bodies. (Usually human proportions are head:body 1:7, but Nok figures are 1:3 or 1:4.)

Totems

Totems are a way of showing the spirits of people's ancestors. We think of people and animals as different – while accepting that both are part of nature. In the past people thought of themselves and animals and plants and rocks as much more closely linked to each other. Spirits could take the form of any object, animal, or person. A group of people all related to one another might believe that they were all descended from a particular animal. Sometimes they believed that a particular animal had helped their human ancestor, perhaps even saved his or her life. That animal, perhaps a bear, a raven, or a killer whale, became their sign and was sacred. It was called a totem. As a member of your group, you might make a carving of your totem and put it in front of your house, you might draw it in the sand, or make an image of it as a mask for your face. You might even mime it or dance it. It was a sacred secret that you shared with the other members of your group.

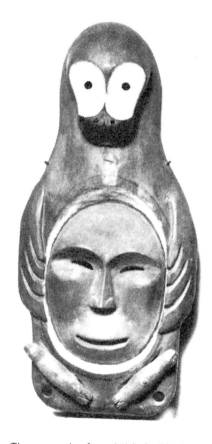

The man who found this in Alaska about a hundred years ago was a bishop. He may not have known at first what it was. It is in fact a wooden mask, in the form of a seal basking on its back in the water, seen from above. The face is the human soul, returning to its animal home. (48 cm high)

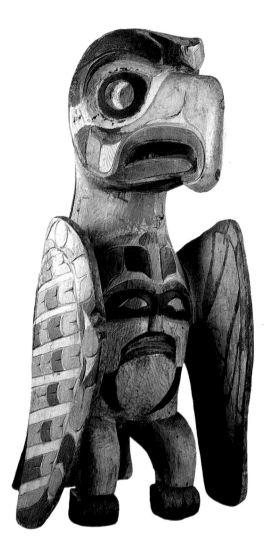

This totem of a thunderbird is from Canada. It is marvellously carved and painted. You can see how its front looks like a human face.

This enormous raven totem used to stand in front of the house of a Chief of the Haida people on the Northwest Coast of America. When his son was in his eighties, the Chief pointed to the place where the totem had been and said, 'It is customary for the nephews of a Chief to keep him supplied with halibut. But do you think this is done any more for me? Not one piece! They want to go to the movies!'

Although the totem no longer belongs to the Chief, it is still used for story-telling in the Pitt-Rivers Museum in Oxford where it now stands.

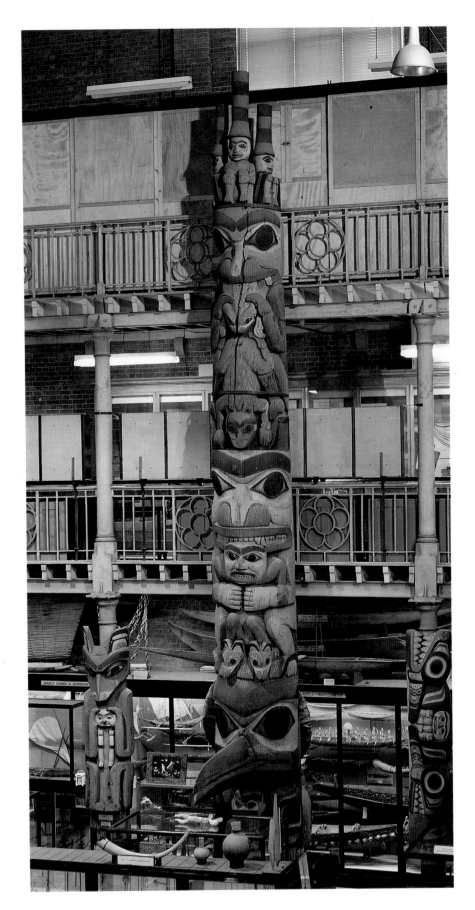

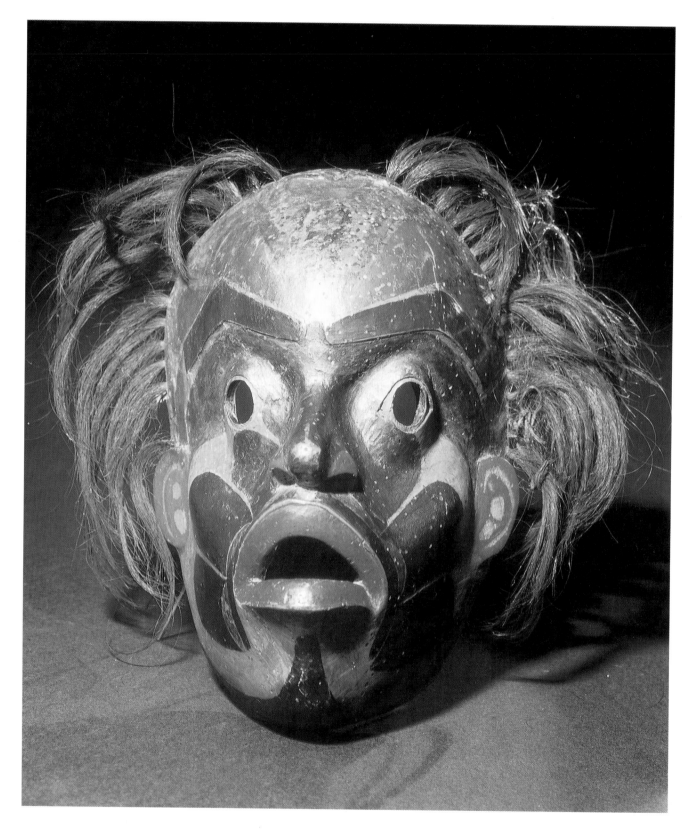

This painted wooden shaman's mask (with real human hair) comes from the
Northwest Coast of America. The shamans designed the masks and sometimes
carved them too. This a very fierce one. Many of the masks were very cleverly
designed with parts that move and fold back if you pull strings.

Masks

Masks, too, were a way of showing spirits. They were often used for religious ceremonies and they were usually strange and frightening. The person wearing the mask 'became' the spirit or god in the ceremony. You can find masks of this kind in many different parts of the world – the demon masks of the Tibetans and the animal masks of the Native American Indians, for example.

In Africa chiefs used to wear animal masks as a sign of power. Some masks were made to be slung on their belts and hung from the left hip (rather like a gun holster?) or worn round the neck. Magicians in Africa and Borneo sometimes wear masks when they are trying to cure people's illnesses.

People also wore masks in the theatre, and sometimes still do. In the time of the Ancient Greeks, about 3,000 years ago, actors always wore masks, either 'tragic' masks or 'comic' masks – depending on the kind of play. Actors in the traditional Japanese 'Noh' plays of 600 years ago also always wore masks, and still do. Today people wear masks sometimes at carnivals and Hallowe'en parties, so that they can behave as they like, without anyone knowing who they are.

Face painting

Another way of making yourself look frightening is to paint your face. Dancers often paint their faces. The Aborigines of Australia do it, and so do the dancers of Papua New Guinea, and the Kathakali dancers of India. The clown you see at the circus is doing the same kind of thing, but he makes his face look sad or happy instead of frightening.

Maybe you have tried it too. When your face is painted to look like a lion or a wolf, you find yourself acting rather like a lion or a wolf. So you can understand the effect masks or painted faces have on dancers or people taking part in a ceremony, and on the people watching them.

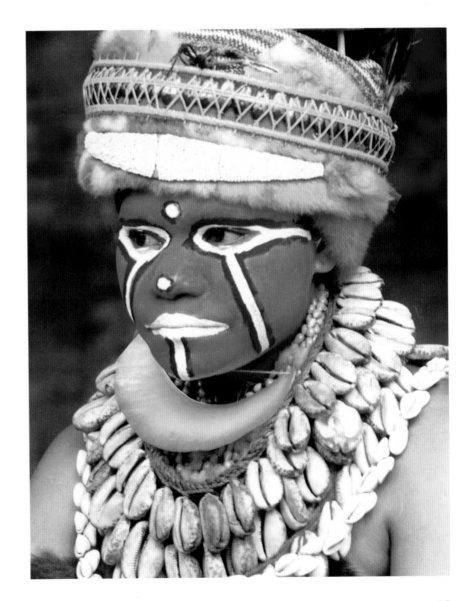

This young dancer from Papua New Guinea has had his face painted. He's wearing a fur cap with bead decoration, and cowrie shells round his neck. One of the older dancers painted his face for him.

4 Telling a story

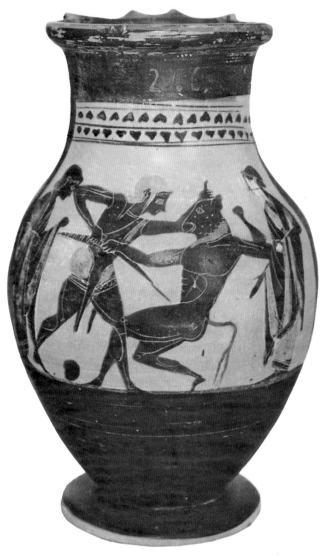

When we think of stories we usually think of books – and of *reading* stories. But it is only in the last hundred years or so that most people in the developed world have been able to read. That doesn't mean that people did without stories. They told them to each other.

Another good way of telling stories is through pictures. The Ancient Greeks told stories in the pictures on their pots. The Romans often carved a series of pictures in stone – rather like a comic strip. You can tell a story by embroidering pictures in a long strip, which is what the people who made the Bayeux Tapestry did, when they told the story of the Norman invasion of England in 1066.

◀ The Minotaur was a monster that was half bull and half man. This was a popular story 2,500 years ago on the island of Crete in the Mediterranean. From that time on, Greek potters often illustrated it on their pots. This jar was made in about 520 BC.

The Romans liked to make stone carvings of real life events – like the earthquake that took place in Pompeii in AD 62.

The city buildings and statues are moving with the earthquake.

Stories galore

The stories that you can 'read' on pots, in paintings, carvings, and tapestries, may be very ancient, or quite modern ones. The old stories are from the myths and legends of ancient peoples – stories that have been handed on sometimes by word of mouth, sometimes written down. These kinds of stories are about heroes and warriors, monsters and dragons, kings and queens, journeys and battles. You have probably come across some of them already – the voyages of the Greek Ulysses, and perhaps the story of the monster Minotaur. Stories are important because they tell people about their past, and give them a sense of their own history. Take stories away from people, and they begin to lose their sense of who they are.

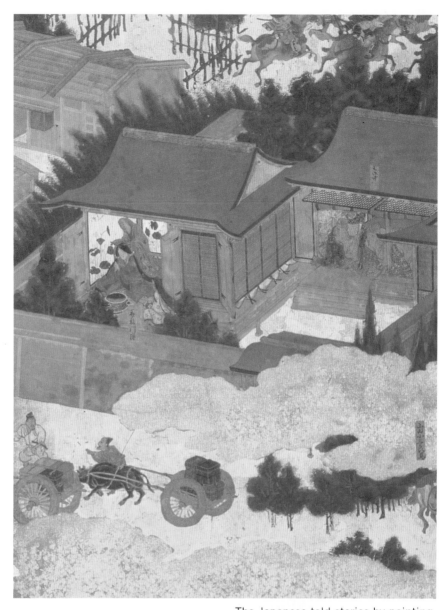

The Japanese told stories by painting them on silk scrolls and folding screens. These too were often about wars and battles. Japan was ruled 400 years ago by warriors. They commissioned artists to paint stories of their victories in rich colours on a gold background on screens, to decorate their castles. Here is part of one of those screens, showing a palace scene. The artist has cut the wall away so that you can see what is going on inside the palace.

The gateway and tower collapse . . . and a mule cart escapes just in time.

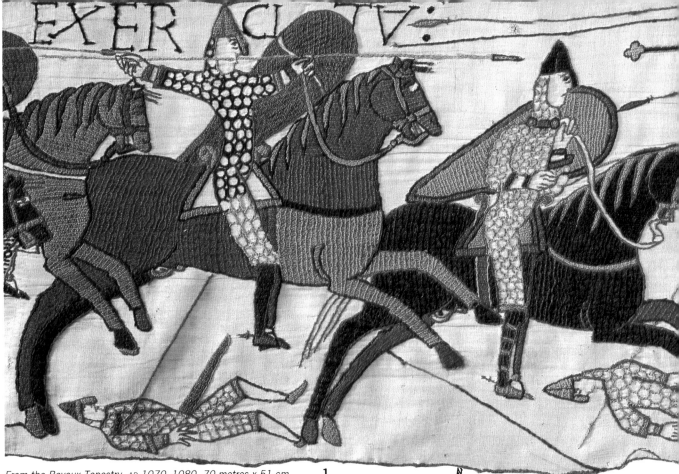

From the Bayeux Tapestry, AD 1070–1080, 70 metres x 51 cm. **1**

The Bayeux Tapestry

The Bayeux Tapestry tells the story of the bitter war between King Harold of England and Duke William of Normandy, which ended with the Battle of Hastings in 1066. Harold lost the battle and the Normans conquered England. It is not really a tapestry at all (a real tapestry is woven) but is made of strips of embroidered linen joined together, each about 2.5 metres long. We do not know for sure who made it. But people think it may have been made in England between AD 1070 and 1080, by teams of embroiderers at the famous School of Embroidery in Canterbury, and then shipped over to Bayeux in Normandy.

There are no speech bubbles, just a few words in Latin describing what is going on. But the figures are shown so vividly that you can understand the action without words.

In this exciting episode, Duke William's Norman soldiers, in their suits of chain mail (**1**), are galloping to attack King Harold's English foot soldiers from both sides. The English are making a 'shield wall' (**2**) and fighting with spears, arrows, and axes. It was a fierce and terrible battle that went on all day.

Hergé, the Belgian artist-storyteller, wrote all his Tintin stories as comic strips. (There are 24 stories and they have been translated into 45 languages!) If you compare this part of *Tintin in America* with the part of the Bayeux Tapestry on these pages, you may make some interesting discoveries. Look at the way Hergé outlines his horses and people. Then look at the way the makers of the Bayeux Tapestry do it. You'll find they both use colour in the same way with areas of clear colour against a plain background. ▶

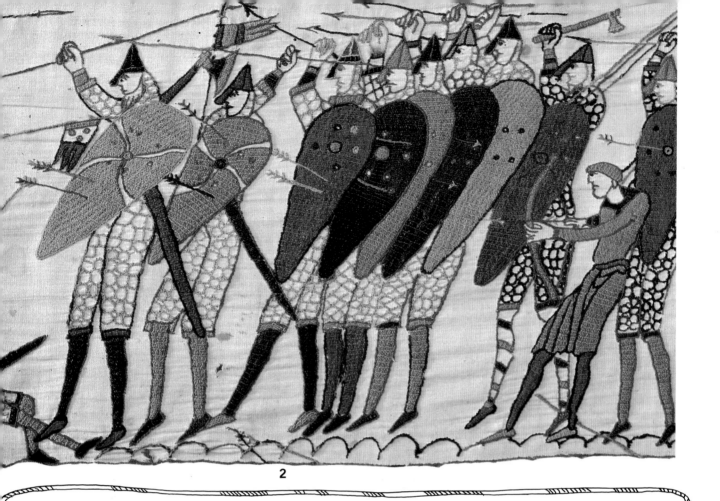

2

Look! There he goes!...Escaping on a horse... someone must have tipped him off when I arrived in town...

OK, Bobby Smiles, we're right behind you!

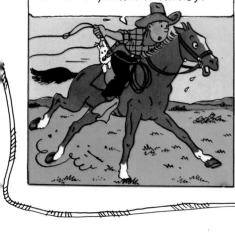

You can't escape, my friend! I'll truss you like a turkey!

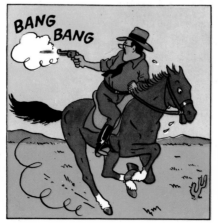

BANG BANG

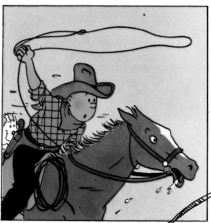

Reading pictures

Many of the stories in art come from the religions of the world. Pictures are a good way of telling religious stories both for those who cannot read and for those who can. They fix a story in the mind. The Christian religion, for example, has hundreds of stories of saints, from St Francis, who preached to the birds and tamed a wolf, to St George, a warrior saint and martyr who, legend tells, fought and slew a dragon and became the patron saint of England. Many of these stories gave painters marvellous subjects for pictures.

Artists all over Europe have painted religious pictures since the Middle Ages, but the painters working in Italy in the 14th and 15th centuries, at the time we call the Renaissance (= rebirth), painted some of the most interesting and beautiful ones ever. Sometimes they painted the story of a saint on a series of small wooden panels, sometimes as a mural on one or more walls. And sometimes they painted different parts of the story all in the same picture.

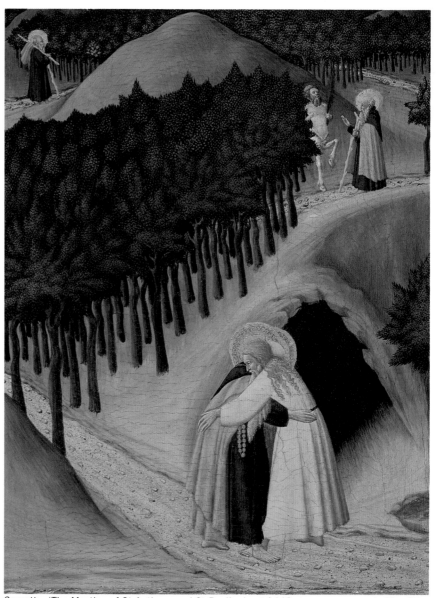

Sassetta, 'The Meeting of St Anthony and St Paul', about 1440, tempera on wood, 48 x 35 cm.

▲ This is the story of a Christian hermit, St Anthony (with a halo), who had a vision of another hermit, St Paul, who was even holier than he was. So he decided to visit him.

The story starts in the top left corner, with the old hermit setting out on his travels, staff in hand. On the way he meets a centaur (half man, half horse), a pagan creature from an older religion. The centaur is beating his breast – meaning that he wants to leave his pagan ways behind and become a Christian. St Anthony blesses him.

St Anthony travels on, down the side of a dark wood, and finally he meets up with St Paul. At this point the two old men embrace one another.

Sassetta, who painted this picture in the 15th century in Italy, near the town of Siena, could have told the story in three separate pictures, but instead he chose to put it all in one picture on one small wooden panel. The story is easy to follow, and the way Sassetta has arranged his picture and the colours he has used make it very beautiful to look at.

Reading windows and doors

In France and in England, in the Middle Ages, Christians built churches and cathedrals with enormous windows. They filled these windows with coloured glass – stained glass, as it is called. These windows often told the great stories of the Christian religion. They showed the stories of Adam and Eve, of Noah and the Flood, of the life of Jesus and the saints. You can read these window picture stories like a book, if you know how to. You usually start at the bottom on the left, read across to the right, and then start on the next line of pictures above that.

Bronze doors made for churches were also used in Italy and Spain for telling bible stories. Some doors had as many as 48 panels, each with a different episode. You are usually meant to 'read' these from the top down, like the lines of a book, but there are some you read upwards, in the same way as stained-glass windows.

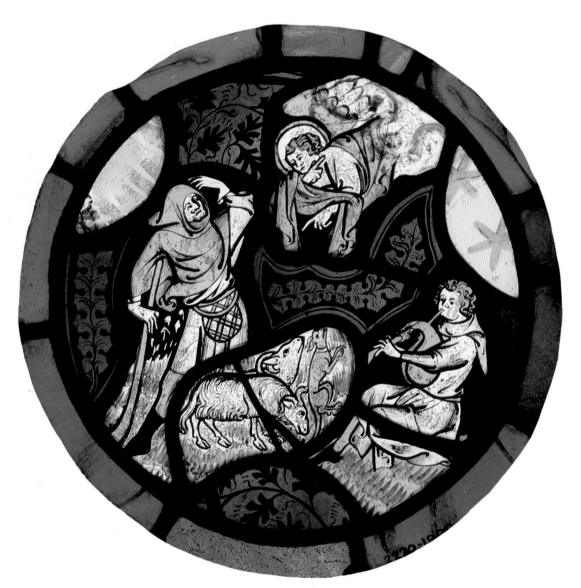

▲ Here is the story of the angel coming to tell the shepherds of the birth of Jesus, a story which every Christian in the Middle Ages would know well. The important parts are picked out in white and yellow. The shepherds are wearing the sort of clothes that people wore in the Middle Ages. One of the shepherds is playing the bagpipes, and the dog is guarding the sheep. This is a small part (29 cm across) of a larger window.

35

For the record

Some stories in art are about wars and battles, earthquakes and floods, disasters and accidents. Photography was not invented until 150 years ago, so before that it was painters who recorded these events. In the past artists were paid to produce portraits and religious paintings by the king, the Church, or rich people – these were their patrons. Rulers and generals hired artists to record their victories and to make them look splendid.

But in the last 200 years artists have begun to earn

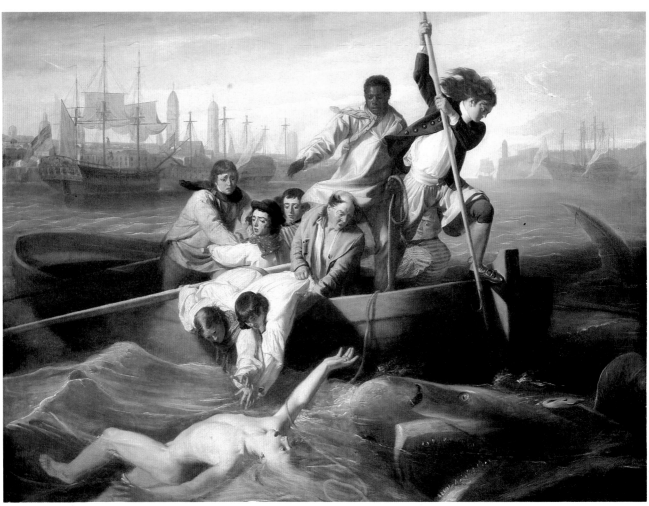

J. S. Copley, 'Watson and the Shark', 1778. oil on canvas, 182 x 230 cm.

▲ Will the boy be saved? Will the shark get him? This painting tells a true horror story. In 1749 a young British sailor called Brook Watson was swimming in Havana harbour in the Caribbean. He was attacked by a shark, which first tore off all the flesh from one leg and then bit off his foot. The picture shows the dramatic moment when the shark is coming in to attack for the third time.

We happen to know what became of young Brook Watson. He did escape the shark's jaws. He became a successful merchant, a member of the British Parliament, and ended up as Lord Mayor of London – with a wooden leg. He had this picture painted to hang in his old school, Christ's Hospital, 'that it might serve a most useful Lesson to Youth'.

John Singleton Copley, who painted this picture, had never been to Havana, but he studied maps and drawings to get the background right.

When this very large and dramatic painting was shown at the Royal Academy in London, the public loved it. Copley must have liked it too, for he painted a copy of it to keep for himself.

their money in other ways as well – from exhibitions and private sales. And so they have not been dependent on getting work from wealthy patrons. They have been free to show in their paintings what they really felt about the events they recorded. An artist like Goya, a Spaniard, showed the horror of war and the misery of poor people, as well as painting portraits of the Spanish royal family.

These painters were doing a similar job to present-day documentary film makers. They were not just recording an event but also giving the feel of it, and making the picture interesting *as a picture*.

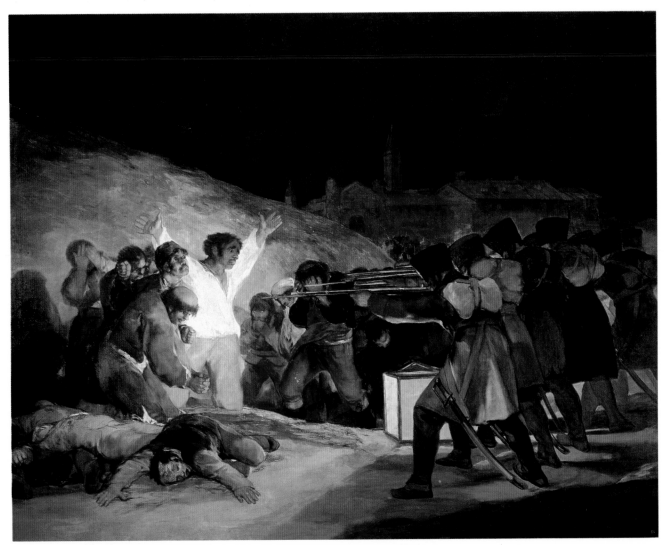

Francisco Goya, 'The Third of May 1808', 1814, oil on canvas, 226 x 345 cm.

The Third of May 1808

At the beginning of the 19th century there was a war between France and Spain. During this war the French took Spanish hostages – and shot some of them on 3 May 1808.

The Spanish artist Goya painted a picture of this six years after it had happened, but when you look at it you feel he must have done it on the spot – like a war photographer.

Guernica

Picasso (1881–1973) painted this enormous picture at the time of the Spanish Civil War. There was an air raid on the small Basque town of Guernica. No one was expecting it and many people were killed. Once you've seen Picasso's painting you do not forget the story of Guernica.

The picture now hangs in the new museum of 20th-century art in Madrid, but it hasn't always hung in Spain. Picasso refused to live in Spain after the Civil War, and would not allow his painting to be shown there while the dictator General Franco was in power. For years *Guernica* hung in New York. After Franco died and Spain had become a democracy, the painting was taken to Madrid in 1981. It was too late for Picasso to see this happen, as he had died in 1973.

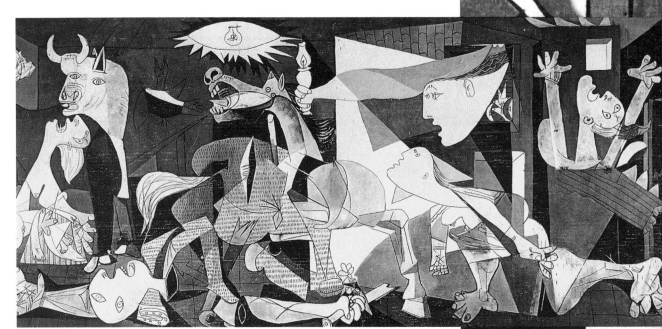

Pablo Picasso, 'Guernica', 1937, oil on canvas, 351 x 782 cm.

Picasso put all his feelings about the horror of war in this figure of a woman with her arms raised. (Perhaps he was thinking too of the earthquake he was in as a child.) Look at the hostage about to be shot in Goya's painting on page 37. It seems to have been painted with the same feeling.

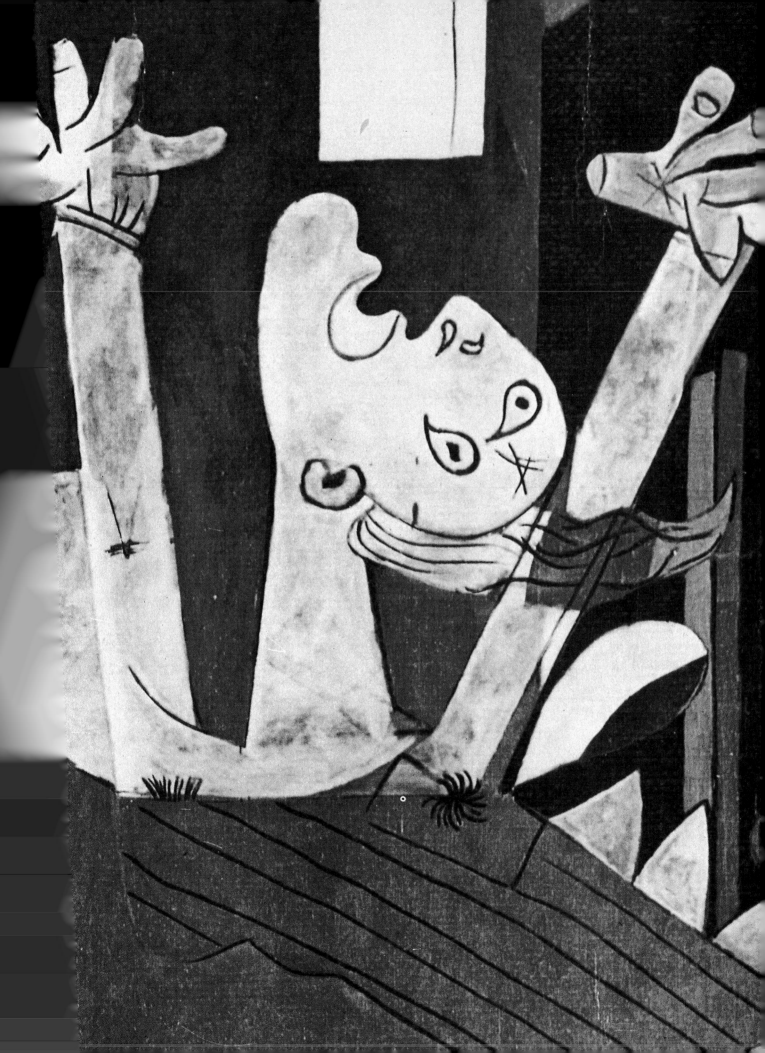

Cops and robbers

People have always found tales of cops and robbers exciting. The Australian artist Sidney Nolan painted a series of 27 pictures based on the life of Ned Kelly, a young bushranger (bandit) who was hanged in 1880. Every Australian knows about Ned Kelly. He and his gang were a legend in their own time.

The Ned Kelly story

Ned Kelly was the son of an Irish ex-convict who had a small farm not far from Melbourne. By the time Ned was 12 he had left school, his father had died, and he was the head of the family. The police caught him helping someone steal a horse, and put him in gaol for three years.

He was a tough man, a marvellous horseman, and a deadly shot. When he came out of gaol, he and his brother and their friends formed a gang and became outlaws. They robbed banks and fought the police, but were friendly towards ordinary people, and always courteous to women. In the end there was a shoot-out and Ned was taken prisoner. He was condemned to death and hanged. He was just 26 and he became a folk hero.

Ned had a black box-like metal ▶ helmet made for himself. (It was quilted inside and quite comfortable.) He wore it when he was out on horseback with his gun. Nolan found he could contrast this black shape very well with the wide yellow landscape and the blue sky. The paint Nolan used was not artist's oil paint but Ripolin, an ordinary enamel house paint.

Sidney Nolan, 'Ned Kelly', 1946, enamel on composition board, detail, whole painting 90 x 121 cm.

'It looks simple but I wanted the maximum feeling of space, so the cloud appears through the aperture in the mask.'

'Kelly had been black, but I put the stripes as though he may have played Australian Rules ...'

Nolan

Ned Kelly in the courthouse, with the judge, the jury, and eight policemen. ▼

Sidney Nolan, 'The Chase', 1946, enamel on composition board, 90 x 121 cm.

▲ Here Nolan paints the policeman galloping off in the opposite direction. Ned's red-and-yellow striped helmet and body covering, and his long gun, make him look like a medieval knight charging in a tournament.

Sidney Nolan, 'The Trial', 1946, enamel on composition board, 90 x 121 cm.

'The tiled floor in red and white was in a house I was in once. Through the left-hand window are sailing ships of the time. The candelabra is true to life.'

The painter in rubber boots

Sidney Nolan (1917–1992) was born in Melbourne, Australia. His father's family originally came from Ireland (like Ned Kelly's family). When Nolan grew up he took all sorts of jobs to earn money while he painted. Once, when he was working on an asparagus farm, he turned up at an art exhibition in Melbourne wearing his working clothes and rubber boots – quite an odd thing to do in those days.

As a child he had seen Kelly's 'armour' at Melbourne's Aquarium, and his own grandfather used to tell him tales of when he was a sergeant chasing the Kelly Gang. Nolan was fascinated by the story. In 1946 he went to see Jim Kelly, one of Ned's brothers, by then an old man, who had been in the gang.

'Hello, are you Ned Kelly's brother, Mr Kelly?'

'Yes I am. But it's none of your business!'

Nolan said once, 'Really the Kelly paintings are secretly about myself.'

He was living with friends called John and Sunday Reed. When he left, he gave all the Kelly paintings to Sunday – just like that. Some years later, Sunday gave them to the National Gallery of Art in Canberra.

Nolan painted many other pictures with Australian themes – landscapes and pictures of people – but never anything more exciting than the Ned Kelly series.

Beginnings and ends

In some magazines and books, there may be a special box, or something printed very big in the centre of two pages, and that is the bit you look at first.

Sometimes it works that way with paintings too. In a picture there may be a 'route' that your eye follows because the artist has planned the composition of the picture to make this happen. In the picture by Sassetta on page 34, the route starts in the top left-hand corner and winds on and on down to the bottom.

With some pictures you find yourself wandering round, piecing a story together from one bit here and another bit there. This happens with *Guernica*. This kind of picture is almost like a film, with close-ups, long shots, and flashbacks. Pieter Bruegel the Elder, who painted in the 16th century in the Netherlands, was a great one for cramming his pictures with all sorts of mini-scenes. In *Children's Games* you can start looking wherever you like and it is bound to be interesting. There are 80 different games shown in the picture, although here you only see part of it.

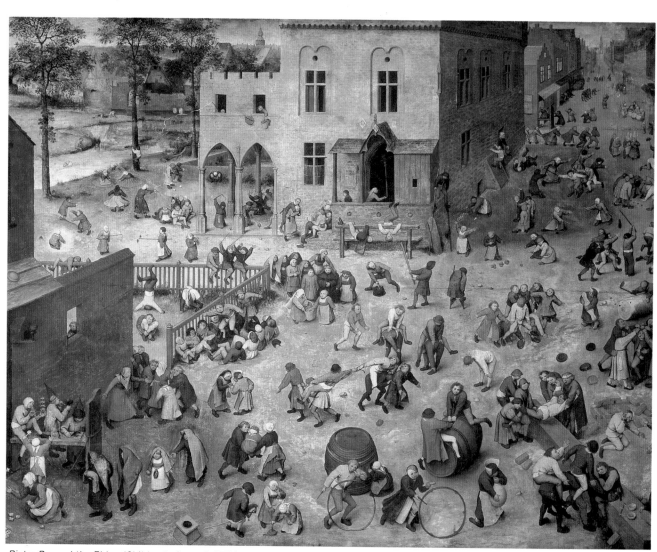

Pieter Bruegel the Elder, 'Children's Games', 1560, oil on canvas, 120 x 180 cm.

5 Face to face

Faces fascinate us. A newborn baby is already able to recognize the pattern of a face. We see faces in all sorts of things – in trees, in houses, in clouds, and in lots of other things.

Maybe you see a face in the moon – that's where the idea of 'the man in the moon' came from. It's as if we were 'programmed' to see faces.

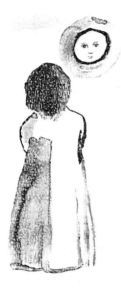

◄ This little girl, drawn by Asun Balzola, sees a face in the moon. Not the man in the moon this time, but the woman in the moon!

▶ The artist Nan Youngman saw a face in a house and called her painting of it *The Laughing Shed.*

Nan Youngman, 'The Laughing Shed', 1967, oil on board, 28 x 34 cm.

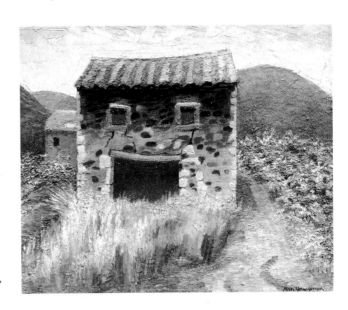

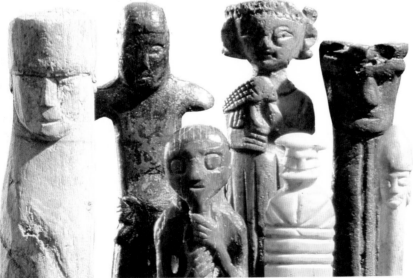

▲ People living a thousand years ago in Sweden used these handy pieces of wood, ivory, and bone to carve heads. Each one is different, perhaps because the materials the carvers started out with were different.
Try making a head out of the cardboard bit of a toilet roll or a plastic bottle or an egg, and see how differently they turn out.

The cartoonist Mel Calman saw a face in a light switch, and added a body to it. Cover up the body. Do you still see the face? ▼

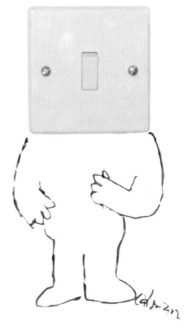

Making faces

When you first started to scribble on paper, you were probably soon drawing faces and learning to make them look happy or unhappy just by turning the mouth up or down. You discovered there are lots of ways of having fun with faces. Maybe in October you make a head out of a pumpkin for Hallowe'en and put a candle inside it. Perhaps you live where there is a lot of snow and you make a snowman – and give him a face with two stones for eyes and a carrot nose.

You can draw faces in the sand with your finger. You can do the same in snow, earth, or even salt. Perhaps the first face that anyone ever drew was just a line scratched on a rock between two marks that happened to look like eyes.

Try to remember what you drew after you started to draw faces. You probably added arms and legs – just lines sticking out from the face, a bit like Humpty Dumpty. But the face was the important part of the drawing – because faces are so important to us.

'My Mum', by Tom Double, aged 4.

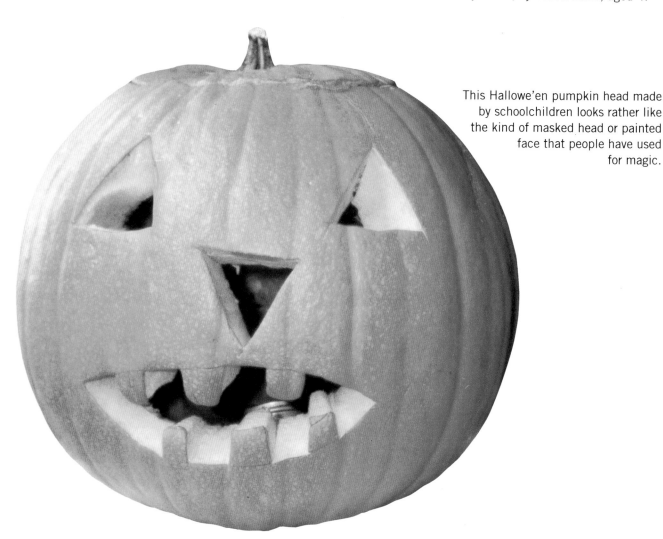

This Hallowe'en pumpkin head made by schoolchildren looks rather like the kind of masked head or painted face that people have used for magic.

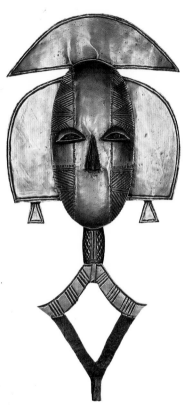

◀ Just the eyes and nose of this figure are enough to tell you that it's meant to be a human being. It's the same kind of idea as the child's drawing on the opposite page. But this is the image of an ancestor in West Africa, beautifully made out of wood with brass and copper.
62 cm high.

The sculptor Norman Mommens made a series of figures small enough to hold in your hand, with faces in the middle of the body. We always seem to look at faces first. Does it make you feel ill at ease that this one is in an odd place? ▶

This is the golden mask that was made to cover the face of a great king when he was buried at Mycenae in Greece about 3,500 years ago. The archaeologist who dug it up, Heinrich Schliemann, believed it had been made for King Agamemnon.
But it was not made to look like Agamemnon or anyone else. It was a kingly face, not a realistic one. ▶

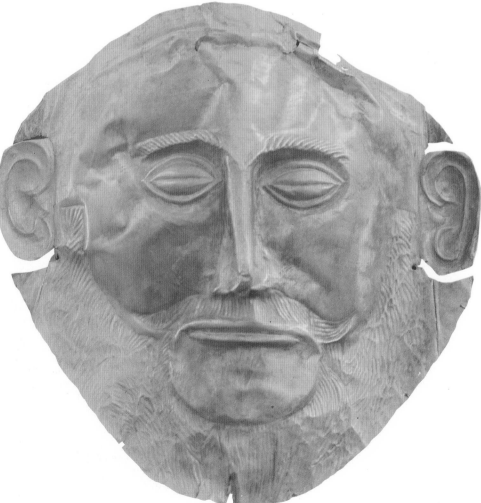

Faces and gods

Human faces and images are important in many of the religions of the world. In some religions it is forbidden to make images of people or animals, because people might worship them instead of the god or gods they represent. In other religions images are valued as a help to people in their worship.

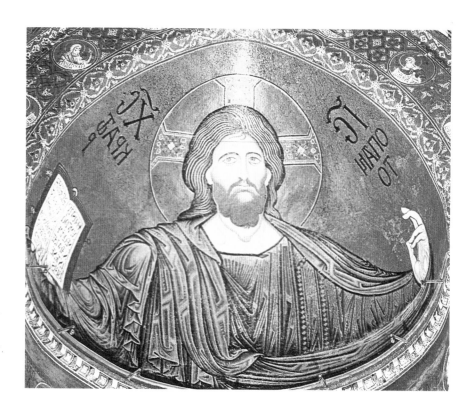

This image of Jesus Christ is made of mosaic and is part of the ceiling of Monreale Cathedral in Italy. It shows him as Christ Pantocrator, which means Christ Ruler of All.

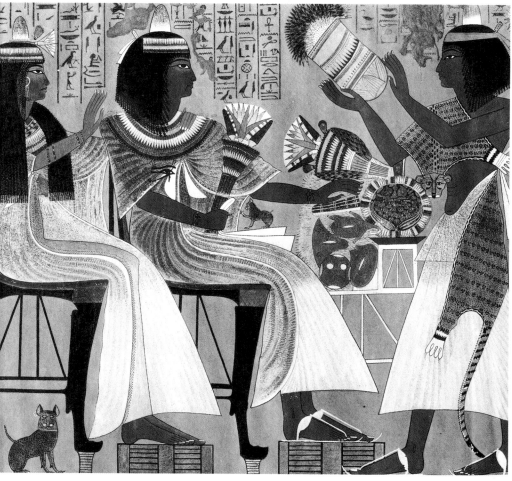

The Ancient Egyptians observed things very carefully. In this picture of the sculptor Ipuy and his wife, their clothes and jewellery are shown in marvellous detail. Even their cat (which wears a silver earring!) is shown, and its kitten. But we don't get any idea of what kind of people they were. That wasn't what the Egyptians were interested in doing when this painting was made for a tomb about 3,500 years ago.

Copy of painting 'Ipuy and his wife receiving offerings from their children', by an unknown artist, restored in tempera in 1920/21, 48 x 74 cm.

'Real life' faces

We are used to the idea of drawing or painting faces to look like a particular person. And we see faces in photographs all the time – in magazines, in newspapers, in books, and in advertisements. But for a long time artists were not interested in making faces look like real people. Their job was to show what kind of person the face belonged to – usually a king, or a queen, or a general. The Ancient Egyptians and Ancient Chinese painted or carved people not as persons but as powerful or important people.

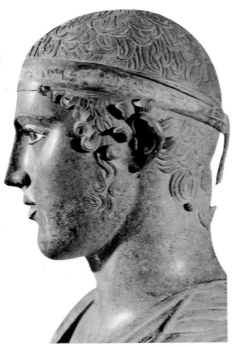

You might meet this young man out jogging, with his sweat band and his curly sideburns. He's a Greek charioteer. This head was made about 2,500 years ago. It is part of a bronze statue found at Delphi, in Greece.

The change came with the Ancient Greeks. At first the statues made in the Greek city-states were very like those of the Ancient Egyptians. But sometime between 2,600 and 2,500 years ago (we don't know exactly, as most of the statues have been lost), Greek artists started to make their stone statues look more like real human beings. Bodies became more natural – and faces too. These ideas spread from the artists who carved in stone to the makers of bronze statues and the vase painters. Other people, including the Romans, started to copy them.

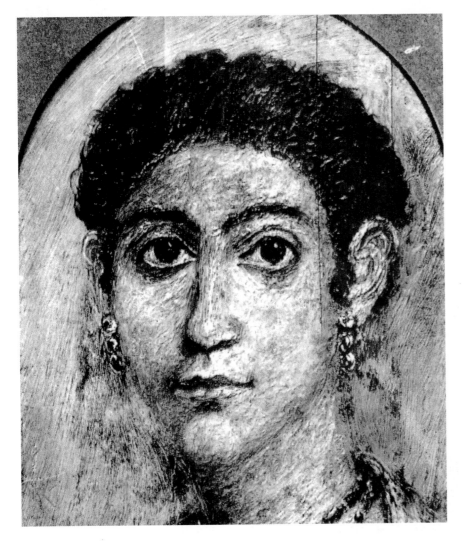

The Egyptians painted portraits on the wooden covers in which mummies were placed. This girl must have died very young. With her large and beautiful eyes, her full mouth, and her head turned to one side, she shows very well how much the Egyptians had learned from the Greeks and Romans about making portraits 'real'. This portrait was painted about 1,900 years ago.

This doesn't mean, of course, that for ever after artists only made faces that looked like real people. But the idea had taken root that it was an interesting thing to do. This means that since that time it's been possible sometimes to look at a carving or a painting and think, 'That man looks just like Mr So-and-So who runs the pizzeria down our street.' People in paintings and sculpture had started to have what we call a 'modern' face. Faces had begun to show their owners' characters.

This was true whether artists were drawing or painting imaginary faces or whether they were making pictures of real people – portraits.

This idea of showing people as they really are has produced some of the most marvellous pictures that have been painted over the last 600 years.

1
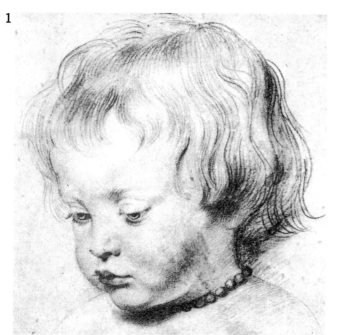

2
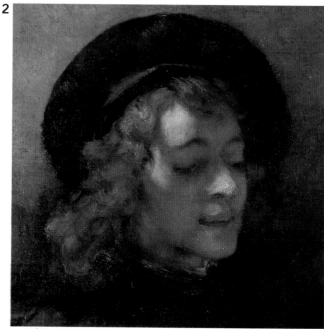

3
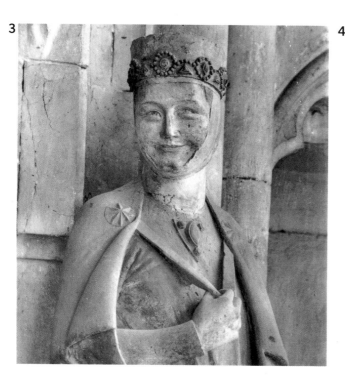

4
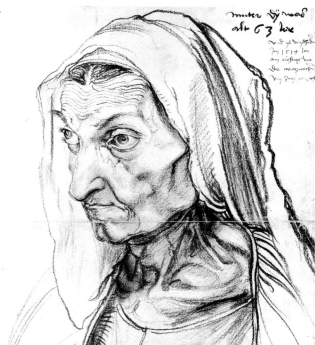

Artists have painted all sorts of faces – beautiful faces, ugly faces, sad faces, humorous faces, faces that move us, and faces that we recognize. Look at the pictures on these two pages, and try making your own character study of each one. It's easy to imagine what kind of people they were. You could try it the other way round too. Think of a particular kind of person, perhaps a mean person or a jolly person, and try drawing a picture of someone like that. Then ask others if they know what kind of a person it is.

1 Rubens (1577–1640) was a marvellous portrait painter and was often asked to paint the portraits of important people such as noblemen and popes. But this drawing of his small son Nicholas, made in about 1620, is different. You feel how fond and proud he was of the little boy.

2 Rembrandt (1606–1669) painted family faces all his life. You feel he has caught his teenage son Titus exactly, with his vivid face, his mouth a little open as he reads, and his glamorous auburn hair a bit untidy. Rembrandt's series of self-portraits, painted all through his life, are an extraordinary record not only of this painter's face but also of the changes in the way he painted. He makes us believe that he is absolutely honest in showing himself as he really was.

3 The 13th-century artist who carved this figure of a German princess on the cathedral at Naumburg in Germany has given her an unforgettable smile. It's as if a press photographer caught a royal princess on her way to the theatre, clutching her cloak around her.

4 Here is the drawing that the German artist Albrecht Dürer (1471–1528) made of his mother. Her face is lined, the flesh is old, and she seems to have lost her teeth. You have the feeling you could meet her on the street today, even though Dürer drew her long ago (in 1514).

5 Here's a man who jumps out of the picture at you, he seems such a real person. But we don't know exactly who painted him (the artist is just called the 'Master of Flémalle'). We don't even know who the subject is for sure.

6 This young man was painted in Italy in the early 1480s by one of the most famous painters of the 15th century, Sandro Botticelli. Perhaps one of his parents had arthritis, for his own hand, with its swollen knuckles, looks arthritic (say doctors who have looked at this picture).

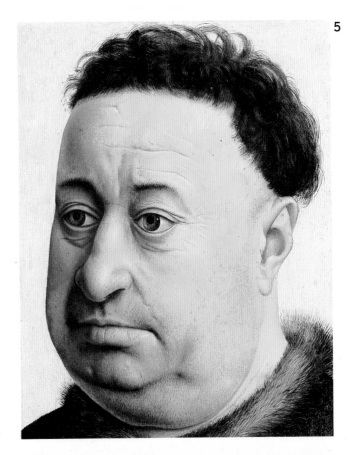

5

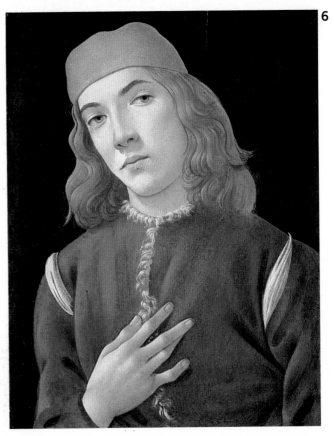

6

Having your portrait painted

Some portraits were included in larger pictures. For example, in the Netherlands 500 years ago it was the fashion for rich people to have a religious picture painted to go in a church. The artist often included small portraits of the donors (the people who gave the money) kneeling at the feet of the Virgin Mary or the saints. Sometimes the donors were painted larger, almost 'rubbing shoulders' with the saints.

There was no photography until about 150 years ago, so having your portrait painted was much more common then than it is today. For artists it was very good for business! Portraits were used in many of the ways we use photographs now – paintings of the children for their mother's birthday or a solemn painting of the board of directors of an institution. If you were a prince you could order a portrait of the princess you were thinking of marrying, to see if you liked the look of her. (Unfortunately, princesses were unlikely to be allowed to do the same!)

This painting by the Flemish artist Hans Memling (about 1430–1494) is a triptych (a picture made in three hinged panels), commissioned by Sir John Donne of Kidwelly (in Wales). It is quite small, so it was probably meant for use by Sir John's family, not to be displayed in a church. Sir John is on the left, under the protection of St Catherine (standing behind him), and his wife, Elizabeth, is kneeling on the right, protected by St Barbara, holding a tower (her 'attribute'). The little girl on the right is probably their daughter Anne. So in this picture there are three members of the family (almost as big as the saints). The side panels show St John the Baptist (left) and St John the Evangelist (right). Perhaps the two saints were chosen because they shared the name of the donor, the person who commissioned the work.

Hans Memling, 'The Virgin and Child with Saints and Donors' (The Donne Triptych), about 1477, oil on oak panel, 71 x 70 cm (centre), 71 x 30 cm (wings).

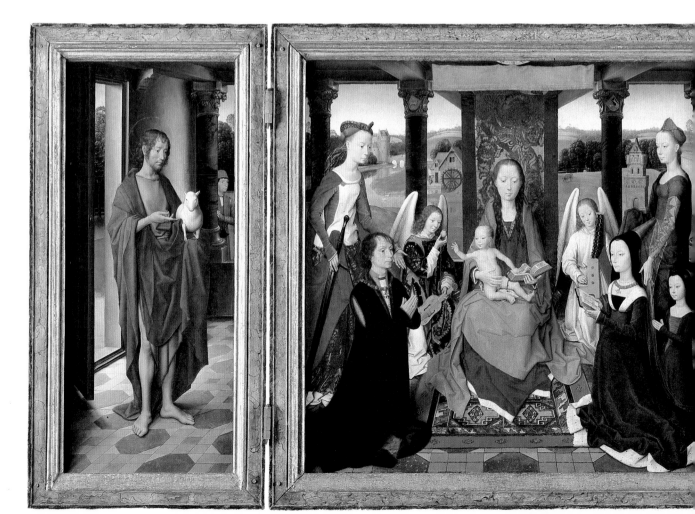

Candles and clues

One of the most unusual self-portraits you could find was painted by the Spanish artist Goya. He has painted himself in his studio, holding his palette and his brushes and wearing his special 'candleholder hat'. His son Javier tells us that his father always painted during daylight, but since he knew that his pictures were often seen in the evening he liked to touch them up in the evening – by candlelight – to make sure that the picture would look its best. For this purpose he had a special hat made with pincers to hold candles!

The picture also gives us some other clues to his way of painting. If you look carefully at his palette you can make out all the colours that Goya liked to use in his pictures and the different kinds of brushes he used. A friend reported that he used his finger and the tip of a knife as well.

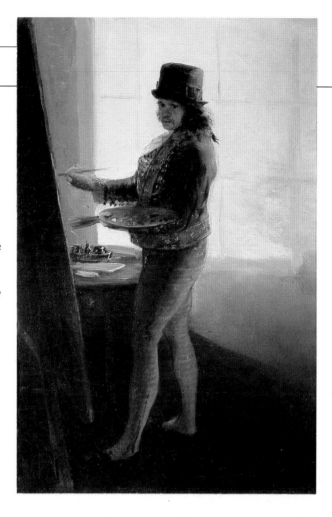

Francisco Goya, 'Goya in his Studio', about 1790–1795, oil on canvas, 42 x 28 cm.

Family faces

The faces that an artist sees most are often those of his family. So it's not surprising that artists draw or paint their wives, their children, and their own parents. (And models in the family come free – unlike others!) The artists know the people well, so these pictures are particularly interesting and often seem 'true' in a special way.

The portraits that artists paint of themselves are special too. They sometimes use themselves as guinea pigs to try out new techniques. And it's interesting to find out how an artist sees himself or herself.

Harold Fordham, 'Self–Portrait with Fried Eggs', oil on board 18 x 28 cm.

Harold Fordham, an artist-tramp, seems to see himself as a down-to-earth prophet or saint.

51

Faces that tell their feelings

Once artists had become interested in showing people as they really were, they started to be interested in showing their feelings.

About 300 years ago, faces in pictures and sculptures started to show feelings more obviously. Suffering saints rolled their eyes up to heaven. People laughed in pictures, and mothers looked lovingly at their babies.

Artists in the 20th century have been trying out a variety of ways of showing feelings in their paintings. They don't always show faces 'the way they are'. They sometimes show 'more feeling than face', as it were. Think of a person's head – eyes, eyebrows, nose, cheeks, mouth, chin, ears, hair. Take a couple of these features and experiment with them. Try drawing them in different ways to look frightened, surprised, happy, sad. Now go through the whole of this book just looking at one feature in all the faces – say the eyes – and see what you can discover about the different ways artists show feelings.

Ian Morton, when he was 12, drew this portrait of his schoolfriend.

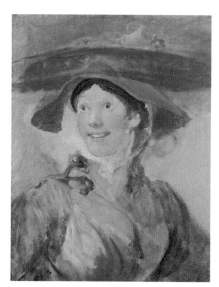

William Hogarth (1697–1764), who painted this picture, *The Shrimp Girl*, described her as 'a blooming young girl of fifteen'. She is so fresh and cheerful that you smile when you look at her.

Picasso, who painted this picture, called it *Weeping Woman*. He painted several pictures with this title, trying out different ways of showing the feelings of sadness and suffering.

Pablo Picasso, 'Weeping Woman', 1937, oil on canvas, 60 x 49 cm.

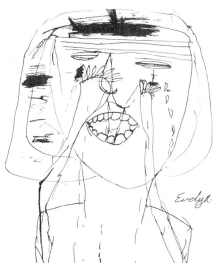

Evelyn (aged 10), who did this pen drawing, called it *Crying Face.*

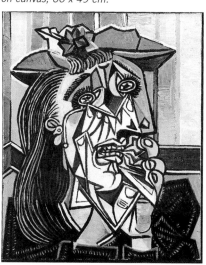

From miniature to mural

You might see the pictures you've just been looking at inside a house or a school or a church, in a museum or an art gallery. But pictures of people come in all sizes. The smallest are only one or two inches high. These tiny pictures, called miniatures, were made to be carried about, sometimes on a chain round your neck, to remind you of your loved ones. It was rather like putting a photo of someone in your wallet. Miniature painters also made tiny portraits of kings and queens and other famous people. These are often a good record of what they really looked like.

At the other end of the scale you'll find people's faces, several yards high, outside. The ones you notice most are probably advertisements or posters, but you may also sometimes find paintings of people on walls, like the one below of the African leader Nelson Mandela, by the black South African artist known as Dumile. (His full name was Mhalabi Zwelidumile Mxgazi, but that was rather a mouthful!) He painted this mural on a wall in New York.

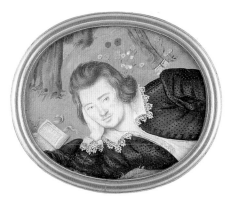

A miniature of a poet, Henry Percy, the ninth Earl of Northampton. The artist was the famous miniature painter Nicholas Hilliard (1547–1619), who painted this piece about 400 years ago. It's a little larger (5cm high) than this photograph.

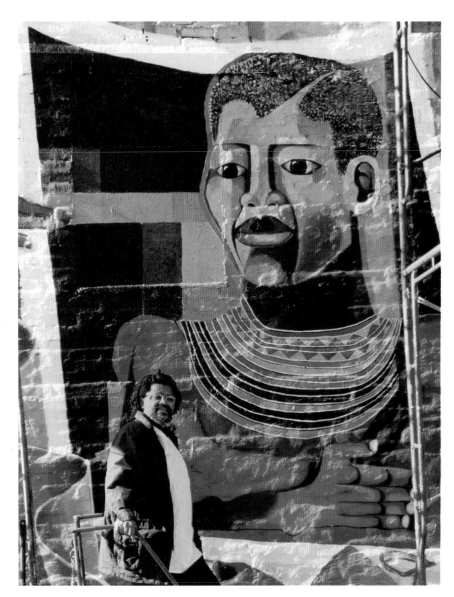

Dumile (1939–1991) stands beside his mural of Nelson Mandela on the Pathfinder Building in New York City.

6 Body language

Think of someone you know. You probably think first of the face. But bodies are important too, and often are as interesting as faces. You can recognize people from a distance by the way they walk or run, sit, or hold their head. Your body is as much a part of your character as your face is.

For artists, bodies have meant different things at different times. And they have thought in different ways about how to show them. The Ancient Egyptians, for example, showed what they *knew* the different parts of the body were like, rather than what they actually *saw* when they looked at a body. You read in the last chapter about the Ancient Greeks making sculptures that looked like real people. And, of course, that meant the whole of their bodies, not just their heads and faces.

In some pictures and sculptures, size is the important thing. The artist may show God much bigger than the surrounding saints. An important ruler may be shown much bigger than his wife or children. Or an artist may make one part of the body bigger than the rest, because it is particularly important for some reason – perhaps a hand giving a blessing. Artists who draw caricatures (pictures which exaggerate particular features of people) always pick on some part of the body, or more than one, to make you see the person in a certain way – to make him or her look funny, or greedy, or stupid, or superior, like the man in the Mel Calman cartoon below.

We know that this Ancient Egyptian figure was a man called Nykure, a granary official. His wife kneels beside him on one side, and his daughter stands on the other side clutching his leg. The women are shown on a much smaller scale than he is – because they were less important than the head of the household. The stone carving is 56 cm high and was made about 4,350 years ago.

I think women need a sense of purpose in life ..

calman

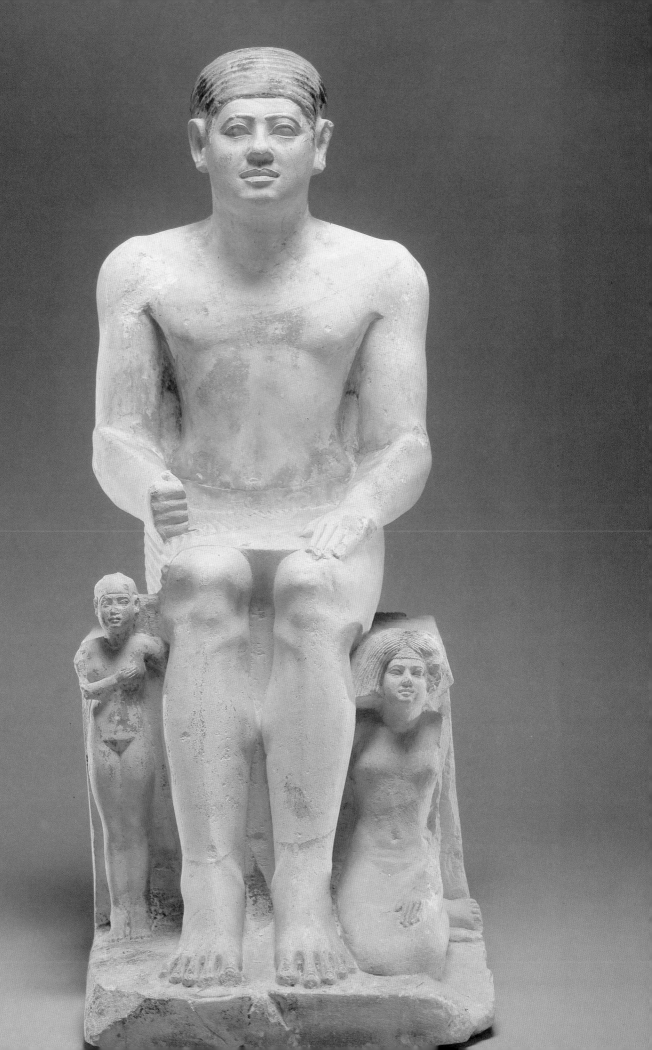

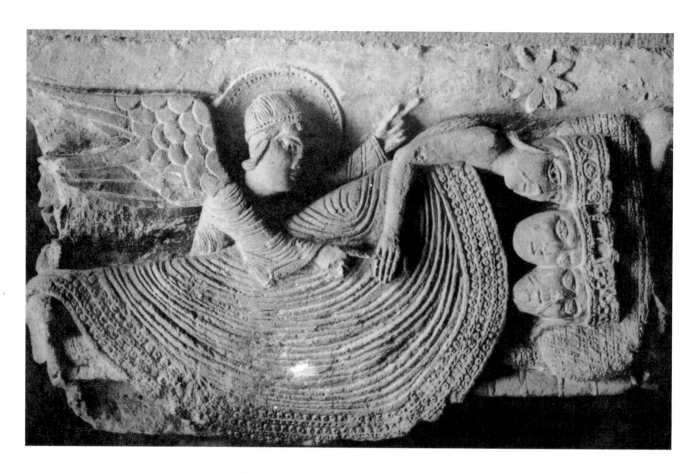

Here is a pair of works of art that are interesting to look at together. They both show people (or a person) in bed, but they do it in very different ways. The carving above is from a church in Autun (in France) and was made about 800 years ago. It shows the three kings of the bible story, the wise men, being told in a dream by an angel not to go back to King Herod to tell him where to find Jesus, but to go home another way. The artist wanted to show all three kings, so he carved them one on top of the other, as if seen from above. He did the same with the cover on the bed. But the angel is seen from the side. The three kings wear their crowns even in bed, so that we know they are kings. The angel touches one king's arm and points: 'Wake up and be on your way!' The whole scene is not at all realistic or natural, but we have no difficulty in understanding what's going on.

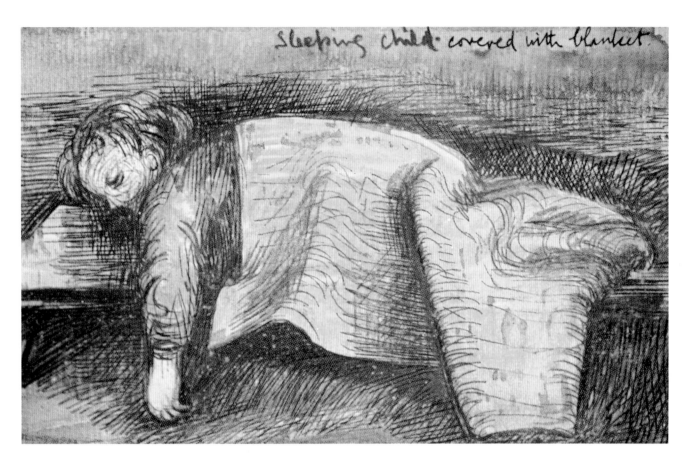

sleeping child covered with blanket.

Henry Moore (1898–1987), one of the most famous sculptors of the 20th century, was an official war artist in the Second World War. He filled a whole sketchbook with drawings of people sheltering in the Underground from the bombing. Families slept there at night. In this drawing he shows a sleeping child. This child too, like one of the kings, has his arm outside the blanket. But how different the scene is. Moore shows the child's body by the way he draws the blanket humped over it. The child looks as if he really is asleep – eyes closed and arm hanging limply down. He looks like any child today asleep in bed.

The 'shelter drawings', as they are called, are a vivid record of what life was like during the air raids on London. But they are more than that. They represent people suffering in time of war, or as refugees. And at the same time for Moore, the shapes and movements of the sleeping bodies were the sources of ideas for sculpture.

Bodies in movement

Artists have a whole range of ways of showing bodies in movement. On the Mediterranean island of Crete about 3,500 years ago, the people who lived there, the Minoans, made 'action' carvings out of ivory, like the bull leaper below. The artist was not concerned about the bone structure or the muscles, but wanted to give the feeling of the way the young men, and sometimes girls, leapt over the bulls, almost flying through the air.

Sports of all kinds have given artists interesting opportunities to show figures in movement. About 3,500 years separate the carver of the Minoan acrobat from three artists in the 19th and 20th centuries who enjoyed studying, modelling, drawing, and painting acrobats and other circus performers. Edgar Degas (1834–1917), Henri de Toulouse-Lautrec (1864–1901) and Marc Chagall (1887–1985) all painted in France. The first two were regular visitors to the famous Cirque Fernando in Paris. They were different artists with different interests, so what they did with the bodies of the performers was, naturally, different. Look at the pictures before reading the captions, and see if you can work out what interested each artist.

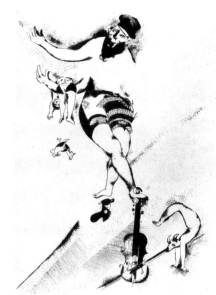

Marc Chagall, 'Acrobat with Violin', 1924, etching, 41 x 31 cm.

Chagall took a number of figures from the circus and put them together in a composition that gives us the feeling of being at the circus, but it's not like any real circus. Whoever heard of an acrobat balancing on a violin? Chagall often put a violin in his pictures, so he puts one in here in a crazy way to suggest the extraordinary things an acrobat can do.

A Minoan bull leaper carved out of ivory, from Knossos in Crete, about 3,500 years ago.

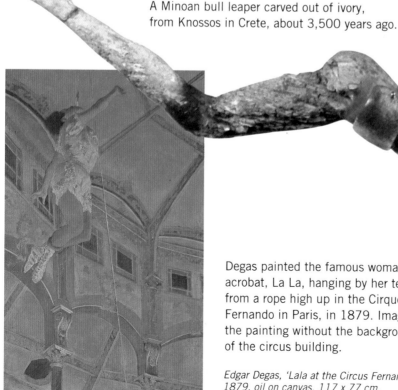

Degas painted the famous woman acrobat, La La, hanging by her teeth from a rope high up in the Cirque Fernando in Paris, in 1879. Imagine the painting without the background of the circus building.

Edgar Degas, 'Lala at the Circus Fernando', 1879, oil on canvas, 117 x 77 cm.

Look at other pairs of pictures on the same subject and guess what it was that interested the artist. Was it the shape the body makes when doing a particular action? Was it the colour? Was it the background? Was it the pattern that the figures make? Sometimes you can get a clue by holding the picture upside down. Try it.

Skaters' bodies make marvellous shapes. The canals of the Netherlands freeze over in winter, so skating is a popular sport there, and was a favourite subject for Dutch artists in the 17th century. The Scottish lochs also sometimes freeze over. In 1784 there was a very cold winter and everyone went skating, including the Reverend Robert Walker, on Duddingston Loch near Edinburgh. The Scottish portrait painter, Sir Henry Raeburn (1756–1823), saw what a wonderful shape the reverend gentleman made in his black clergyman's clothes, ◀ and painted him.

Henry Raeburn, 'Skating on Duddingston Loch', 1784, oil on canvas, 76 x 64 cm.

Tracy Beresford painted this picture, Happy Skaters, for a competition when she was a child. She was more interested in colour than shape. She got the feel of balancing with your arms and the sense of fun very well. ▶

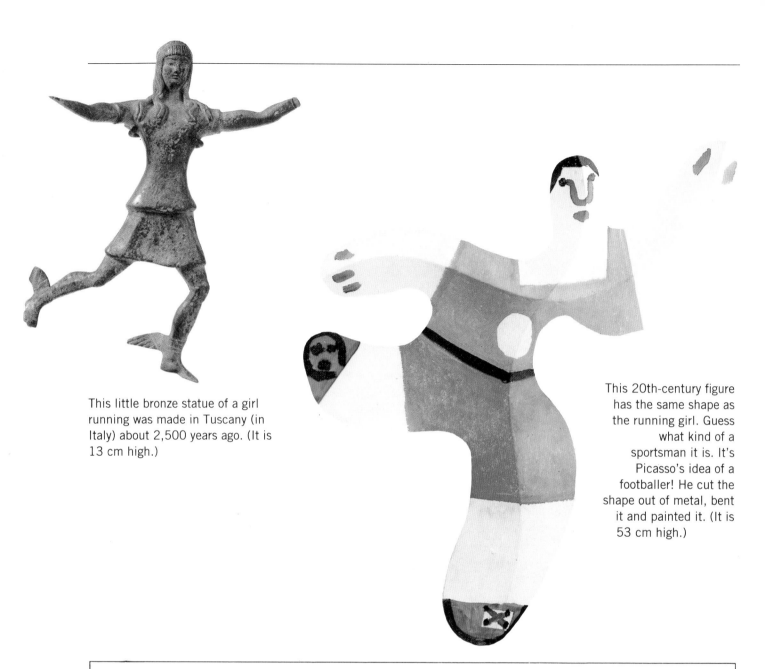

This little bronze statue of a girl running was made in Tuscany (in Italy) about 2,500 years ago. (It is 13 cm high.)

This 20th-century figure has the same shape as the running girl. Guess what kind of a sportsman it is. It's Picasso's idea of a footballer! He cut the shape out of metal, bent it and painted it. (It is 53 cm high.)

Alphabet bodies

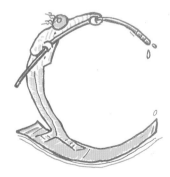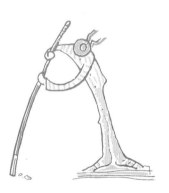

You can fit bodies into all sorts of shapes – even into letters of the alphabet. This young artist, Frances Campbell, has made her letters of the alphabet out of the bodies of Cambridge punters and their boat poles. You could try making letters out of the figures of footballers, dancers, skiers . . .

Another way of showing a body in motion was used by the makers of Indian religious figures. When they made a figure of a god dancing, they showed him with *two* pairs of arms, each arm in a different position. It's almost as if the arms are actually moving.

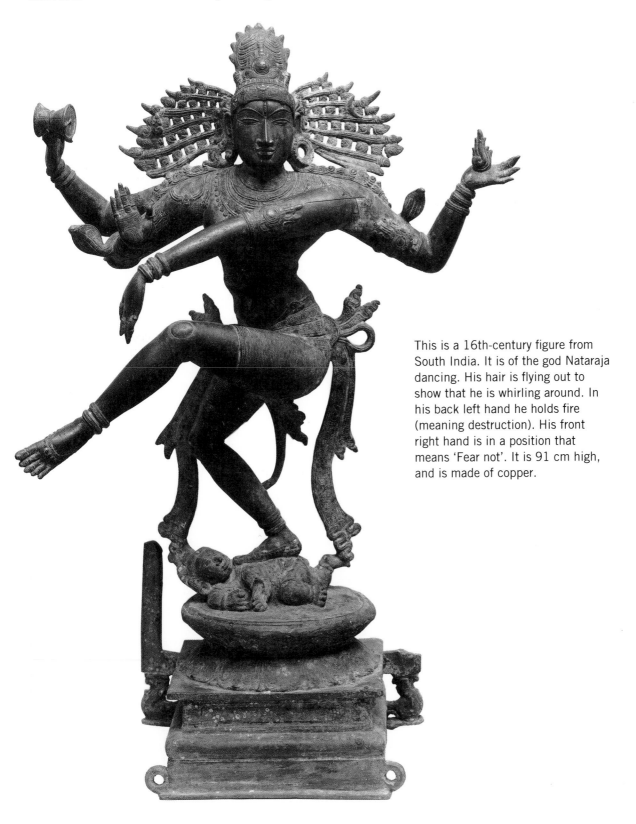

This is a 16th-century figure from South India. It is of the god Nataraja dancing. His hair is flying out to show that he is whirling around. In his back left hand he holds fire (meaning destruction). His front right hand is in a position that means 'Fear not'. It is 91 cm high, and is made of copper.

Bodies at work

Another way of showing figures in movement is to show people at work. The artists who decorated Ancient Greek vases showed women weaving, sculptors at work, dancers, and sportsmen. The Ancient Egyptians made small clay figures of people doing a variety of jobs – sometimes to bury in tombs. The Romans showed butchers and bakers in the panels they carved out of stone. And artists who illustrated the Books of Hours (religious books) in the Middle Ages included many scenes of country people at work – ploughing, haymaking, shearing sheep, pruning vines. We can learn a lot from these models and paintings about the way people lived, what they looked like, and what clothes they wore.

The same 19th-century artists who were interested in acrobats and dancers found people at work good to paint too – people gardening, breaking stones, hanging out the washing, ironing . . . Degas was just as interested in painting a woman doing the ironing as he was in painting a young dancer practising.

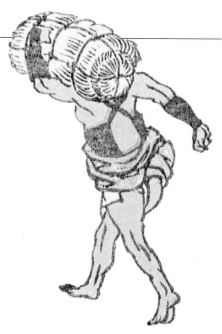

The Japanese artist Hokusai (1760–1849) was well known for his drawings and prints of people. He made sheets of drawings of men and women at play and at work – like this peasant who is carrying a heavy sack of grain.

Vincent Van Gogh (1852–1890) went to work as a preacher among the miners in a poor area of Belgium. There he drew the miners at work – including these women miners carrying sacks of coal on their heads. Later, when he went to live in Provence in southern France, he liked to paint people at work in the fields.

Vincent Van Gogh, 'Women Miners', 1882, 32 x 50 cm.

This is the illumination for the month of October from the Book of Hours, *Les Très Riches Heures du Duc de Berry*. The Duc de Berry was a great collector and patron of the arts in 15th-century France. He commissioned the illustrations for this book from the Limbourg brothers, three well known young artists who worked together on illuminations (and who all died before they were 30).

The scene is just outside Paris. In the background is the palace of the Louvre (as it then was). The man in red is riding a horse, which is drawing a harrow to break up the ground. The one in blue carries a sling full of seed, and is sowing it by hand. The figure in the middle is not an archer practising, but a scarecrow! (Today scarecrows have sticks or guns, but then they had bows.)

The artist has shown the men's bodies moving naturally, as they set about their tasks. But there are other interesting 'natural' points about this picture. Look at the figures again. You'll see that they cast shadows, even the tiny figures in the background, and that the boat on the river is reflected in the water. Nothing very special about that, we think. But this small picture (almost the same size as on this page) is the oldest example we know of an artist showing shadows and reflections. It was the start of looking at light in a different way.

'October', from 'Les Très Riches Heures du Duc de Berry', a 15th–century manuscript.

Pairs and groups

Once an artist starts to include more than one figure in a drawing or painting, or groups figures together in a sculpture, all sorts of new things can be tried out. The artist can make the figures link, or contrast with each other. He or she can make things happen between them.

A favourite subject for artists is that of mother and child. The most popular pair of figures in European art is the Madonna and Child (the Virgin Mary and Jesus), because so much of the art of the Western world arises out of the Christian religion. If you think of the different ways in which mothers hold their babies, you can imagine the enormous variety of paintings and sculptures made on this theme. And, because Jesus was no ordinary baby, it has been a challenge for artists to try and show the special quality of this child and the special relationship between him and his mother.

The mother and child pair also appears in many paintings that have nothing to do with religion. Mary Cassatt (1844–1926) was an American painter and printmaker who worked mostly in Paris. She admired the work of Degas very much. She first saw one of his paintings in the window of a picture dealer. 'I used to go and flatten my nose against that window and absorb all I could of his art. It changed my life.' She loved painting mothers and children.

The Boating Party is a mother and child pair, but it is much more than that. The shapes of the boatman, of the sail, and of the boat itself, are very important parts of the picture. Try to imagine what the picture would be like without them. Now imagine the mother and child in clothes like those in the picture below the Cassatt. Would the picture then look like a Madonna and Child? ▶

◀ The sculptor who carved these figures of the Madonna and Child out of stone lived in Lombardy, in the north of Italy, in the 12th century. For him, it seems, the important thing is the tenderness between mother and child. It could almost be any mother and child. (The statue is 74 cm high.)

Mary Cassat, 'The Boating Party', 1893/94, oil on canvas, 90 x 117 cm.

◀ Andrea Mantegna, the son of a carpenter, lived in the north of Italy from about 1431 to 1506. This gifted boy was adopted by his teacher so that he could use Andrea's talents without paying him. Mantegna painted six Virgin and Child pictures. In this one the shapes of the mother and child fit into each other perfectly. They are bound together not only by the child's sleeping head, which is cupped by its mother's hand into the hollow of her neck and wrapped around by her veil, but also by the feeling of closeness that they give. Like the carving from Lombardy, these are religious figures, but could also represent any mother and child. The picture is painted in distemper on canvas and is 42 by 32 cm.

Before radio and television, cassette and CD players, people had to make their own music. They made music in their homes, in church, and in concerts. People singing and playing instruments together was an interesting subject for artists, and became a very popular one.

Here are two works of art both made in Italy at the time of the Renaissance. The group of child singers (left), carved out of marble by Luca della Robbia (1400–1482), is part of a larger frieze of angels and children singing, dancing and making music. He made it for Florence Cathedral, and you can see it there today in the cathedral museum. The boys are all reading the words out of the same book, so they have to lean over each other's shoulders to see it. Luca della Robbia has used this opportunity to link them in an unusual way, overlapping them and using their arms to lead your eye from one body to the next.

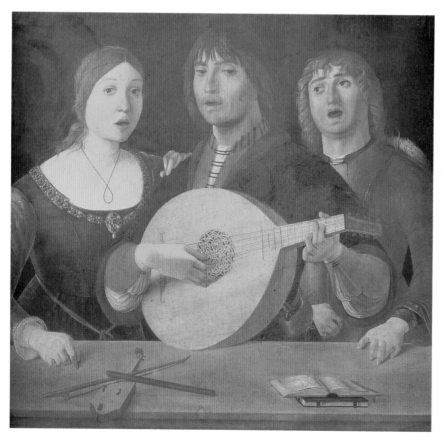

Lorenzo Costa (about 1460–1535) painted two young men and a girl singing to a lute. He has painted them standing very close together – the girl has her hand on the lute-player's shoulder. This gives you the feeling that they must be singing in close harmony. Look at their eyes. They are all looking in different directions.

Lorenzo Costa, 'A Concert', about 1499, painted on wood, 95 x 76 cm.

Clothes carry messages

It's easy to recognize a policewoman or a fireman, a nurse or a Scout – you recognize them by their clothes, their uniforms. At a football or baseball match, you can recognize the supporters of the two teams by the scarves or rosettes they wear – that's a kind of uniform too. There are special ties that some men wear that tell you, if you're in the know, that they belong to the local Gliding Club or that they went to a particular school or university. The clothes these people wear carry particular messages. In the same way, some people's clothes carry more general messages: 'I'm wearing designer jeans – so I'm fashionable', etc.

Clothes in art carry messages too. You can recognize a Japanese samurai (warrior) by his clothes and his swords, a Roman emperor by his special toga. The religious orders of monks and nuns in the Middle Ages and at the time of the Renaissance wore particular 'habits' – for example, the Franciscans wore brown, and the Dominicans black and white.

Clothes in portraits often carry messages about wealth and power. You can see this very clearly in portraits at the time of Henry VIII and Elizabeth I. The clothes are made of precious silks embroidered with jewels, and often padded out to make the wearer look powerful. We sometimes still talk about 'power dressing' today.

Hans Holbein the Younger, 'The Ambassadors', 1532, painted on wood, 207 x 209 cm.

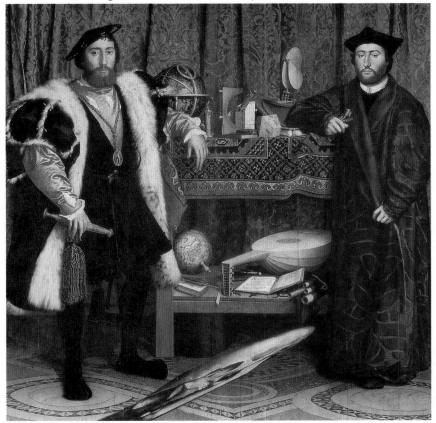

This picture by the German artist Hans Holbein the Younger (about 1497–1543) is usually called *The Ambassadors,* because it shows (on the left) Jean de Dinteville, who was French ambassador to England at the age of only 29, and his ambassador friend Bishop Georges de Selve (aged only 25), who went to visit him in London. (Why do they both look so much older than their ages?) The French ambassador is a marvellous example of power dressing, with his enormous padded shoulders, silk tunic, fur-trimmed coat, and gold chain of office round his neck. His friend is more soberly dressed, as befits an ecclesiastical gentleman, but even he has a robe of fur.

The picture is interesting for a number of other reasons. There are a lot of *instruments* in it – a globe of the earth and one of the heavens, an instrument for finding the position of the stars, two sundials (one portable), and two quadrants (for measuring heights). There are also musical instruments – a lute and a case of flutes. Besides these, there is a hymn book and an arithmetic book. Perhaps these objects stand for human skills and knowledge. Or perhaps they are just there to show the wide range of interests that these two men had in the sciences and the arts.

But what is that strange diagonal shape on the floor? You can find the answer by lifting up this book so that it is level with your eyes and looking at the shape from that position. You should see something that reminds you of death. Holbein may have meant it to remind us all, however powerful we are, and however much knowledge we have, that we all have to die in the end. So in this picture it is not just the clothes that carry a message but the objects as well. It is a large picture, nearly 2 metres square, and was painted by Holbein when he was working for Henry VIII.

7 Decoration

To keep warm, stop the draughts, have something to hold your food and drink, you need very little. Straw, a sack, a leaf, a hollow gourd will do. So why have people spent so much time, energy, and money on making things that are to do with everyday life so complicated – and sometimes so beautiful? It is a question to which there is no simple answer. The wish to make our surroundings more interesting and beautiful than they need be is one of the things about people that makes us different from animals.

It would be hard to guess what this object is for. It is an Ancient Egyptian covered spoon for holding cosmetics, in the form of a girl being towed through the water by a gazelle. It was made about 2,400 years ago, from alabaster (a kind of stone) and slate.

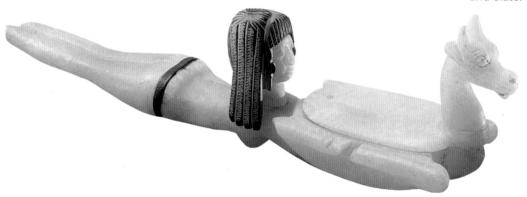

Next your skin . . .

We start with our bodies. When we use make-up, arrange our hair, or paint our nails, we are doing the sort of thing that people have been doing for thousands of years. The ways in which people have decorated their bodies have taken different forms at different times.

Girls often wear eye make-up today, just as the women of Ancient Egypt did. Hindu women wear a red dot, the tilak, on their forehead – both as a decoration and as a religious sign. As soon as people started using cosmetics they needed small boxes to hold powders and ointments. And then they began to decorate their boxes. You only have to look along the shelves of any beauty department in a big store today to realize how people like to have their cosmetics and perfumes attractively 'packaged'.

Compare the hairstyles of the Nok man of about 2,300 years ago (page 25), the Japanese man wearing a kimono 200 years ago (page 20), and the young man in Florence about 500 years ago (page 49) with this photograph of a punk couple. You'll see how differently men have arranged their hair over the ages. What one person thinks is beautiful, another person – perhaps in a different part of the world – thinks is ugly.

Jewellery

Ornamenting the human body is perhaps the oldest art there is. Wearing jewellery is one of the main ways men and women make themselves look beautiful. It may be made of gold or plastic, of silver or ceramics, and include precious gemstones such as diamonds or emeralds, or not-so-precious amber, pebbles, or beads.

Jewellery also carries messages, as clothes do. Probably the best-known piece of 'message' jewellery is the wedding ring. But rings carry all sorts of other messages – an engagement ring, a mourning ring (to be worn when someone close to you dies), or a bishop's ring (which shows the wearer is a bishop). Crowns, necklaces, bracelets, anklets, ear rings, nose rings, neck rings, and brooches can all tell us about the person wearing them. The more precious the materials from which the jewellery is made, the more important the person is likely to be.

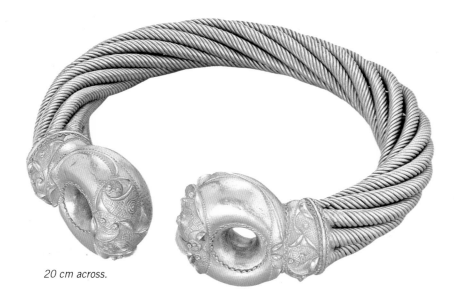

20 cm across.

This is a torc, which is a piece of jewellery once worn round the neck by a chieftain, or a king. This one is made of a mixture of silver and gold (called electrum). It was dug up at Snettisham, in Norfolk in the East of England, and is about 2,000 years old. Other torcs made of electrum, gold, or bronze, have been found in Switzerland, Germany, France, Belgium, and Ireland. These countries (and others in Europe) were where the Celtic peoples lived from about 2,400 years ago until the Romans conquered them 400 years later. They were famous for their metalwork art – particularly jewellery, in which they used complicated patterns based on the forms of animals, plants, and people.

The Ancient Egyptians used gold and gemstones such as amethyst, garnet, and particularly turquoise, not just for ornamenting a person's body, but sometimes also as 'message' jewellery for a ruler to wear. Often it was buried with the ruler, to go with him or her into the next life.

In Europe the Ancient Greeks also were very skilled at making jewellery. Later on, in the Middle Ages, jewellers used their craft mainly for religious objects – Christian crucifixes (crosses) or boxes for holding relics of saints (bones for example), and crowns for kings, queens, and emperors. People in Central and South America often used silver and gold, as there was a lot to be found in countries such as Mexico and Peru. Much of the jewellery made in Europe from the 16th century onwards was made out of the gold and silver that the Spanish and Portuguese took from Central and South America.

Badges and emblems

Most people collect something at some time in their life. What do *you* collect? Perhaps beer mats or old bottles, stamps or postcards. Or badges and stickers? Collecting badges goes back a long way. In the Middle Ages, you would not have gone on holiday (holidays are a modern invention), but you might have gone on a pilgrimage to a holy place. In Europe many Christians made a pilgrimage to the church of St James of Compostela, in Spain, just over the border with France. Pilgrim routes led from all over Europe to Compostela. (You can still walk on some of them.) The emblem of St James was a shell (like the one that the Shell oil company uses as its emblem). Large numbers of badges were made, usually of tin, in the form of a shell and sold to pilgrims. They were like tourist souvenirs.

Some of these badges were very beautifully made, like miniature sculptures. Those for pilgrims to Canterbury, to the shrine of St Thomas à Becket, often show St Thomas riding on horseback, or sailing back from exile in a boat. The sun was often included in pilgrim badges – not because it had anything to do with the saints, but because it was a sign from an older religion of sun worship that had got absorbed into the newer religion of Christianity.

8 cm across.

The pilgrim badge above is from the 14th century. It shows the head of St Thomas inside a sun. The one below shows a sun inside a moon.

A 20th-century pilgrim badge!

Horse brasses

Here is a horse brass based on the sun.

Not only do people have badges, but animals and machines do too. Before vans and trucks took over, town streets were full of horse-drawn carts delivering goods. In the country all the machines and farm carts were drawn by horses, not tractors. The horsemen and carters were proud of their great cart-horses, and decorated their leather harness with polished brass discs, called horse brasses. About 3,000 different designs have been found, but they are nearly all based on three patterns: the crescent, the heart, and the sun. The horse always wore one with the sun design on its forehead. The original idea was to protect the horse and its driver from the evil eye. It is interesting to compare horse brasses with pilgrim badges. The designs are often quite similar, and you'll notice that the sun is used for both, and it is still used to decorate many of the things we use today.

Diamonds and hearts, roses and leaves

All round the world, people decorate the things they make with patterns. These may be geometric – an X, a zigzag, or a diamond – or represent a flower, perhaps a rose, or a leaf, a tree, or a heart.

The objects that people decorate are made of many different materials. All sorts of people whose work depends on daylight, the weather, or the seasons, have traditionally made and decorated objects in their spare time. Shepherds, for example, often worked with wood, whiling away the hours spent watching their sheep by carving sticks and shepherds' crooks, and making little boxes for their girlfriends. In America, Europe, and parts of Africa and Asia, people made beautiful wedding chests. Often the same kinds of decoration, of flowers and leaves, birds and fishes, are painted or carved on wedding chests from different parts of the world. The quilt shown on this page shows similar patterns. The men and women who designed quilts like this a hundred years ago created complicated arrangements of rosettes, suns and stars, leaves, feathers, chains, and diamonds.

Decorated or plain?

This shepherd's crook in the form of a fish is made from a sheep's horn, and the duck's head below is the top of a walking stick.

Is it more fun to have a walking stick with a duck handle than a plain one? Is it more interesting, for example, to have a brass door-knocker in the shape of a dolphin, a boat with a figurehead in the form of Lord Nelson, a bench end in church carved as one of the Seven Deadly Sins? Not everyone likes the idea of decoration. Religious sects such as the Quakers and the Shakers (in America) thought everything should be plain, with no decoration.

Lovers' knots formed the traditional centrepiece of wedding quilts in the North of England.

The man who made this box for his beloved carved his name and the date into the design of rosettes, heart, and lovers' knot.

Part of a quilt made by Elizabeth Sanderson (1861–1934) in Northumberland. See how many motifs you can find.

Round the house

Where there is no refrigerator or running water in a house, containers for storing foods and liquids are very important. They have to do their job efficiently – they must not leak, they must keep their contents clean and cool, and they must keep out animals and insects.

10,000 years of pots

Clay pots have been doing this very well for the last 10,000 years. 'Pottery' may be the simplest and plainest terracotta (= baked earth) pots for everyday use, or the finest and most beautifully decorated 'art' pots, meant more for looking at than using.

The oldest pots were made by modelling the pot from clay, or building it up from a coil of clay (like a long sausage). About 4,500 years ago the pottery wheel, more or less as we know it today, was invented. (You put the clay on a revolving disc and form it with both hands.) That made it possible for potters to produce many more pots much more quickly – and in more regular shapes. About a thousand years later, potters began to use glaze (a hard coating that was baked on to the pot), which made the pots waterproof, and so better for storage.

We probably all use pottery in some form or other every day of our lives. Here's a child's plate and mug. It is an old German pattern, with a black cock and hen. Cocks and hens keep popping up in the decoration of all sorts of things, from wind vanes to chests, from toys to textiles.

The peoples round the Mediterranean needed to store water, wine, and olive oil, so many of their pots are designed to hold these liquids. Potters experimented from earliest times with different forms of decoration. Simple scratched lines developed into geometric patterns. First there were primitive drawings of animals, later more realistic pictures. It seems a long way from the bold and lively octopus design of the pot on this page – about 3,400 years old – to the illustrations of stories that the Ancient Greeks painted on their vases a thousand years later (like the one on page 30).

The native peoples of Central and South America have a long and interesting tradition of pottery for everyday use. They often made their pots with geometric patterns cut into them or painted on them. Sometimes they made a whole pot in the shape of a head, or used a head as a handle.

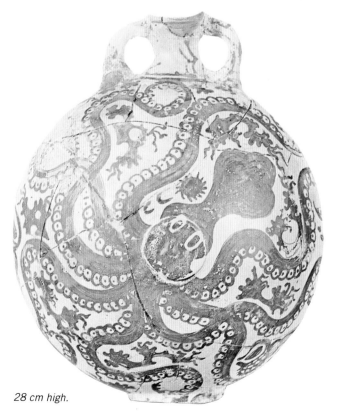

28 cm high.

This pot, made in Crete about 3,400 years ago, is a pilgrim flask. You can imagine a hot and weary pilgrim trekking to some distant shrine gratefully taking a swig from it (rather like a hiker drinking from a plastic water bottle). It could be hung from string passed through the handles at the top. There were lots of octopus in the sea round Crete, and so it was natural for the potter to use one as his decoration. The octopus suits the shape of the pot.

Round this page you can see a few of the many Botswana basket patterns and their names.

Forehead of the zebra

Running ostrich

100,000 years of baskets

Clay is not the only cheap material around for making storage containers. In many places – particularly Central and South America, Africa, and Asia – people use grasses, reeds, cane, bamboo, raffia, and bark for making baskets. We tend to think of baskets as something we use for shopping. But baskets have a hundred other uses. They can be used for drying food in the sun, for storing it, or for carrying a meal (like a luncheon box). Baskets are used as traps for catching fish and birds, and as cages for animals and songbirds. They can be used for storing clothes.

There are two ways of making baskets. You can either weave them or coil them. In Africa it's not really a job for specialists . In almost every village you can find many ordinary people skilled at making baskets. Their sizes and shapes are as varied as their uses. In Nigeria alone people have counted as many as 30 different types of rectangular basket. The traditional patterns are just as varied. Zulu ones are made up of lines, triangles, and diamonds, and Botswana ones of circular patterns.

Ribs of the giraffe

Roof of the rondvel (hut)

A selection of Botswana baskets made from palm fibre. The Different colours of the fibre are used to create a variety of patterns.

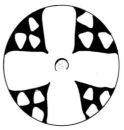

Flight of the swallow

Cellini's salt-cellar to end all salt-cellars!

Benvenuto Cellini (1500–1571) came from Florence and was both sculptor and goldsmith. He kept a journal, which still exists, and so we know a lot about him. He gives a very vivid picture of life in a goldsmith's workshop in Rome – his commissions for jewellery from flirtatious noble ladies and from Pope Clement VII himself, his rivalry with other goldsmiths, his travels, his friends, his love affairs . . .

After about 20 years in Rome, he moved to France, and designed this extraordinary gold salt-cellar for Francis I (the same King of France for whom Leonardo worked). He must have been very pleased at the King's reaction to it:

'When I showed this piece to his Majesty, he gave a great cry of astonishment, and could not take his eyes off it.'

Then something nice happened:

'He told me to take it back back to my house, saying that he would tell me at the proper time what I should do with it. So I carried it home and sent at once to invite several of my best friends. We had a jolly dinner together, placing the salt-cellar in the middle of the table, and so we were the first to use it.'

Cellini describes his salt-cellar:

'The Sea [shown as Neptune] carried a trident in his right hand and in his left I put a ship of delicate workmanship to hold the salt. Below him were his four sea-horses, fashioned like our horses from the head to the front hoofs; all the rest of their body resembled a fish . . . I had portrayed Earth in the form of a very handsome woman, holding her horn of plenty. By her right hand I placed a little temple, most delicately wrought, to contain the pepper.'

1543, 34 cm wide, 27 cm high.

Jacks of all trades – and masters of all

As well as making and decorating things to use from cheap materials, people have also wanted to surround themselves with objects made out of precious materials, such as silver and gold. There is a tradition in some parts of the world of making very fine objects for use on the tables of the rich. These are the work of silversmiths and goldsmiths.

Today we usually think of painters painting pictures, of sculptors making sculpture, of potters making pots, of silversmiths making silver objects, and so on. Most artists specialize. But it has not always been so. At the time of the Renaissance, for example, many artists were very ready to take on commissions from patrons for different kinds of work. Well-known artists did not consider it beneath them to design coins, medals, jewellery, furniture, or fountains. You find painters who were sculptors, sculptors who were architects, and so on. The most extraordinary example of this is Leonardo da Vinci (1452–1519), who came from Florence and worked for noble patrons in both Italy and France. He was painter, sculptor, architect, military engineer, and mathematician. Arising from his own curiosity and interest, he also invented things (including a primitive flying machine) and wrote both about scientific matters and about painting.

Another famous artist of the Renaissance, Michelangelo (1475–1564), who was a painter, sculptor, and architect also made designs for the decoration of his buildings, while Raphael (1483–1520) was well known in his lifetime not just for his paintings but also for his decoration designs for buildings.

So far as we know, Leonardo's flying machine was never built in his lifetime. But in 1987 a full-scale model was made – with a wing-span of 11 metres. Leonardo was sure that the way to invent a flying machine was to study the bone structure and flight of birds.

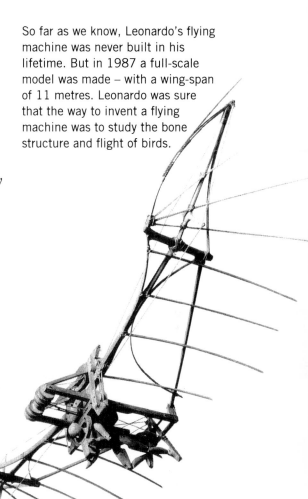

On his way to France in 1537, Cellini stayed with Cardinal Bembo, a famous scholar and poet, and he designed this portrait medal of his friend. Cellini tells us in his journal that he spent 200 hours on the wax model of the portrait (**A**), but only 3 hours on the winged horse Pegasus (**B**) for the other side of the medal. Bembo was puzzled: 'This horse seems to me ten times more difficult to do than this little portrait on which you have bestowed so much pains. I cannot understand what made it such a labour.' But he liked it, and gave Cellini three horses in return.

Decorating floors and walls

Your house may be built of brick, stone, concrete, wood – or a mixture of these. The roof could be of tile, slate, stone, thatch, iron, or plastic. But there are many kinds of dwellings in the world that are made in quite different ways.

Rugs on the move

People who are nomadic (who move from place to place with their herds of animals) live in tents or light-weight dwellings, so that they can easily take them down, carry them, and put them up again somewhere else.

These Afghans are wrapping a kilim round the frame of their traditional yurt tent.

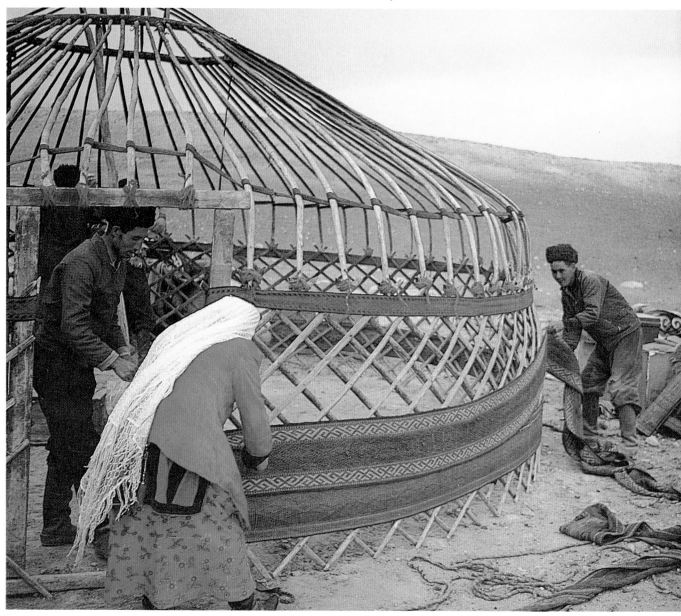

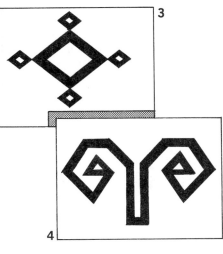

Some examples
of kilim patterns:
(**1**) birds
(**2**) ram's horns
(**3**) eye
(**4**) hand.

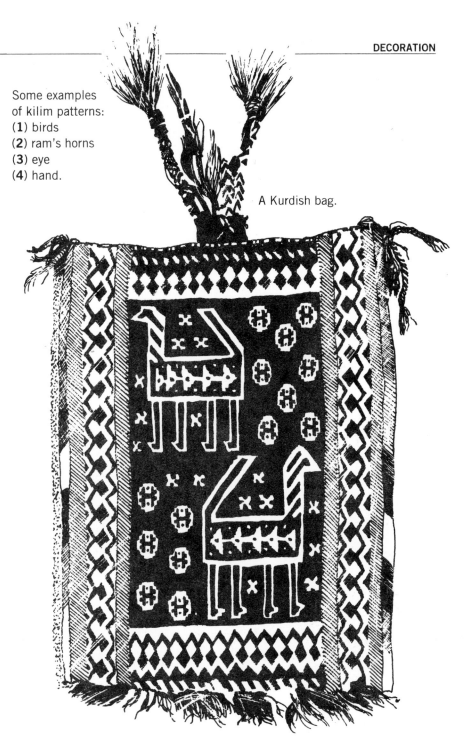

A Kurdish bag.

Some nomadic peoples, in Iran and Afghanistan for example, use long strips of woven cloth to cover the frames of their tents. They make rugs for the floor and weave saddlebags to carry their belongings on horseback. They do not own many things, so they make the most of their kilims (rugs and hangings), making them in rich colours (using natural dyes) and in a great variety of patterns.

You see the same patterns in kilims (geometric patterns, Tree of Life, eyes, hands, birds, animals) as you find in folk art in many different parts of the world.

This Flemish tapestry shows a scene from the series *The Hunt of the Unicorn*. In the Middle Ages, the story was that this imaginary creature, a horse with a single horn, could only be captured by a virgin allowing it to rest its head in her lap.

'The Unicorn in Captivity', about 1500, tapestry of wool, silk, and metallic threads, 368 x 251 cm.

Tapestries on the wall

In the Middle Ages the palaces of the rich must have been pretty cold and uncomfortable, with their stone walls and floors. People hung woven tapestries over their walls, both to make the rooms warmer and to decorate them. Many of these tapestries are works of art, with most beautiful pictures of flowers and animals. Some come in a series, so that the artist could illustrate a story in several instalments round a room (rather like a painted fresco).

Jean Lurçat, 'Le Chant du Monde', 1958, tapestry, detail of 'L'Homme en Gloire dans la Paix', whole piece 437 x 1320 cm.

In the 20th century, artists have taken up tapestry again – but not for practical use. The French artist Jean Lurçat (1892–1966) designed a remarkable series of tapestries that now hang in the town of Angers in France. It is called *The Song of the World*, and it tells the story of Man from the Creation to the Nuclear Age. He called this part of it *Man in Glory, at Peace*. Remember the other images you have looked at, and try to work out the meaning in this tapestry of the sun, stars, owl, tree, the leaves, and the hands.

Tiles, patterns, and pictures

You can find tiles in schools and shops, bathrooms and banks, fireplaces and fishmongers. You may also find them in mosques, churches, kitchens, dairies, pubs, underground stations, and town halls, in fact more or less anywhere where it is useful to have a hard surface that is easy to clean. The word 'tile' comes from the Latin word *tegula*, which means 'cover'. And that's just what tiles do very well – provide a cover for walls, floors, roofs, and even whole buildings. Tiles are made of pottery and easy to decorate.

▲ This is part of a panel of tiles showing how tiles were produced in the 18th century.
1 & 2 Two workers are making tiles, using a tile frame.
3 A boy is shovelling away the leftover clay.
4 A man is stacking the half-dried tiles.
5 A worker is trimming the tiles.
6 A dog is asleep on the floor!

▲ Whatever you put in the corner of a tile will join up with the three corners next to it to form what is called a 'link' pattern or design. The shape in the corner of these 17th-century Dutch bird tiles is called an ox-head design. You can see why.

Dutch potters learned about tile-making from the Spaniards, and since the 17th century there has been an important tile industry in the Netherlands, which still goes on today.

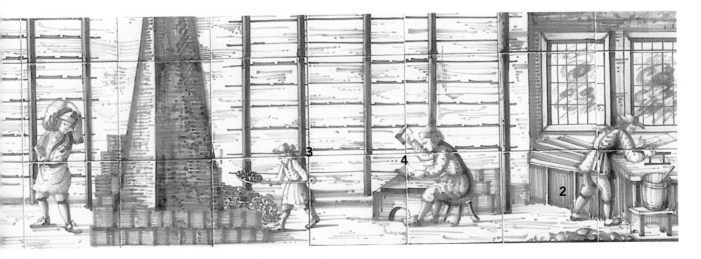

Tiles go back a long way – to the Ancient Egyptians (as so many other things do). The Egyptians used blue glazed bricks (sort of tiles) to decorate their houses, and they also used them for making pictures. Tiles have to be made in shapes which fit together to cover larger areas of floors or walls. Most tiles nowadays are square, but it is also possible to make them in other shapes, such as rectangles and stars. (You probably know about tessellation, so you will be able to think of other shapes that fit together.) The interesting thing about designing tiles is that you can make a mini-pattern on each tile, which then becomes a maxi-pattern when you put several tiles together.

Some of the most interesting and beautiful tiles are found in those parts of the world where Islam is (or has been) an important religion – Iran (Persia), North Africa, Spain, and Portugal, for example. These are hot countries, and so cool tile surfaces are suitable here. (The same is true of mosaic – small pieces of glass or ceramic stuck together to form a hard covering for floors and walls.) The tiles are decorated with patterns, both geometric and flowers and leaves, and with birds. (In Islam it is forbidden to show people in art.)

A blue and white tile, made about 1425, showing a peacock, from Syria, in the Middle East.

Games, toys, and amusements

If you watch very young children playing, you'll notice that some of their favourite toys are the plainest and most simple – wooden spoons, empty tins, bricks. It is adults who are so keen on decorating games and toys (like everything else). From the time of the Ancient Egyptians to our own day, we have had a colourful tradition of carved and painted toys and games. Some of them are very simple, like the whistling pottery cocks you find from Scandinavia to Mexico.

A pottery folk art cock from a Christmas market in Finland. It whistles when you blow into its tail.

Some game pieces and toys are very beautiful, like the chessmen you find in all sorts of different styles in, for example, India (where the game of chess came from originally), China, Japan, Italy, Spain, and Scotland. Others have complicated machinery and were quite high-tech in their time, like the silver swan automaton that bends its neck and appears to gobble up silver fishes, to the accompaniment of music.

Today's inexpensive toys and amusements are sometimes tomorrow's valued antiques. There are still markets and fairs in some European countries, and in Africa and Asia, where you can buy toys and ornaments traditional to that part of the world. It can be quite fun to wonder which of today's toys, amusements, and ornaments are going to be valued by people in a hundred years' time.

The *Silver Swan* automaton made in the workshop of James Cox in about 1773. It can be seen working every afternoon at the Bowes Museum in Barnard Castle in the North of England.

This piece is a Bishop from the 78 chessmen discovered on the Isle of Lewis off the Scottish coast, in 1831. They are beautifully carved, with Celtic decorations, out of ivory. They are probably about 800 years old.

This automaton is called *Tipu's Tiger*. It shows a splendidly fierce wooden tiger (about life-size) eating a European wearing a hat. Tipu was an Indian ruler who hated the British and loved tigers. If you turn the handle in the side of the tiger, air is pumped through bellows to produce growls and cries, and the man moves his arm up and down.

8 Making art

Have you ever worked as part of a group of people painting a mural, or making a paper frieze picture or a collection of puppets? If you have, then you will have some idea of how artists worked in the past.

Workshops

The marvellous gold objects that have been found in the tombs of kings and queens of Ancient Egypt were made in workshops. The stone figures of saints and prophets that you see on the front of medieval cathedrals, the marble friezes that the Romans carved, and the large fresco paintings of Renaissance Italy were all made by teams of people. There was always someone who made the plan – the owner of the workshop, the master builder, or the leader of the team. There was also a whole group of craftspeople, some very skilled, some still learning, who worked with the master. Those still learning, the apprentices, worked on the first stages: roughly hewing out figures from blocks of stone, preparing wooden panels for painting, putting the first coat of plaster on a wall ready for a fresco. That way they learned a lot about the materials and techniques. Cellini's salt-cellar was designed by him (see page 74), but we know from his journal that much of the detailed work was done by goldsmiths under his direction.

Working together

In the 20th century too there are many examples of people working as a team on a work of art. In 1966 a group of artists, led by Tjebe van Tijen, decided for fun to make the longest drawing in the world – to stretch from London to Amsterdam! The drawing went over pavements and up walls, into a taxi cab, over the taxi driver himself, through Heathrow airport, into a plane, out again at Schiphol airport, across the tarmac, by bus into Amsterdam, along the streets, and finally disappeared into a gutter outside the Stedelijk Museum. Paul Klee said drawing was 'taking a line for a walk' – these artists were certainly doing that!

This was a great day for the children from a group of Oxfordshire schools. A thousand children, their parents, and a puppeteer had made big puppets to act out an Anansi story. (There are lots of stories about Anansi in Africa and the Caribbean.) They made Anansi himself, his mother, two leopards, a serpent, hornets, a magic fairy being, a tarbaby, and biggest of all, the great sky god. They used old pram wheels, old clothes and rubber boots, wicker, pieces of leftover cloth, a rucksack frame, paper, and pieces of plastic rubbish.

Using assistants

Even with single pictures, often more than one person worked on the same painting. With a portrait, for example, the master might sketch out the whole picture, then the assistants in his studio would paint the clothes the sitter was wearing, and the master himself would do the head and perhaps the hands and the finishing touches. Sir Anthony van Dyck (1599–1641), who had trained in Rubens' workshop and was one of the best known and most successful British portrait painters in 17th-century England, had everything very well organized. He used to set down his ideas for a new portrait, with the sitter in front of him, on a little piece of blue paper. Then the design was marked out on the canvas by assistants. The head itself would be painted by Van Dyck himself, and most of the costume by the assistants in his studio.

Sir Peter Lely (1618–1680), another very successful English portrait painter, went even further. He had a 'stock book' of patterns for poses and clothes, from which the sitter could choose. Lely painted only the sitter's head, and then told his assistants to paint, for example, 'whole length No.8 and clothes No.1'. It was almost like painting by numbers – or ordering a meal in a Chinese restaurant. No wonder another painter said, rather cattily, that all Lely's pictures were brothers and sisters.

SCHOOL OF BOTTICELLI

Sometimes in museums and art galleries you may see a label saying: 'from the Workshop of X [famous name]', or 'School of Y [another famous name]'. This means that we don't know exactly who painted it, but we do know that X or Y had something to do with it. They may have painted parts of it, or the person or people who did paint it may have learned from X or Y.

What you make depends on what you make it out of

Here you can see a number of objects, all animals. They are made out of many different materials – that is, they use different media. See if you can guess what these objects are made out of. (The answers are given below.)

1 Clay 2 Clay 3 Soapstone
4 Plaster 5 Brass 6 Glass 7 Wood
8 Clay 9 Copper 10 Wood 11 Wax
12 Soapstone

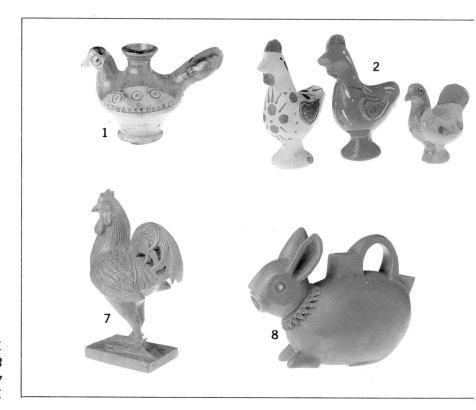

From eggs to concrete

It's easy to think of art as something only to do with paint and paper or canvas, with wood or stone, with clay or metal. But you can use anything you like. Here are some of the things artists use in different parts of the world. You can probably think of some more to add to the list.

snow glass

bronze

rice

Soapstone

sand nylon

plastic wax chalk

eggs skin bark milk

gold plaster

ink tea wool brass silk straw

reeds clay roots bone charcoal rope

copper leaves gemstones ice

wood

coconut concrete stone iron

paint

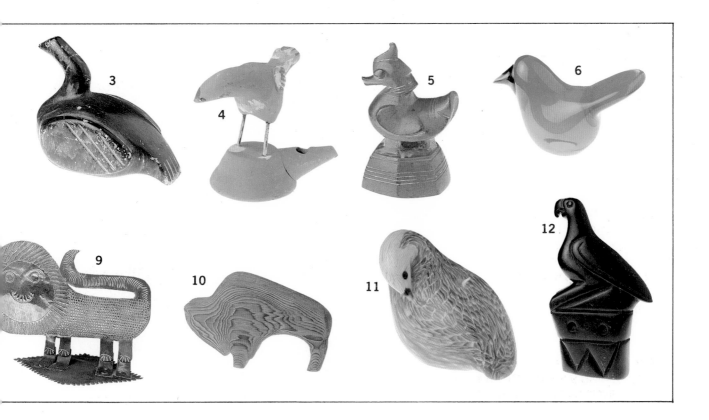

85

If you use poster paints mixed with water to paint a picture on a piece of paper, you will end up with a very different picture from the one you would produce if you used egg and water to mix colours ground from berries and metals to paint a picture on a wooden panel. (Before oil paints became popular in the 15th century, artists used 'tempera' – the egg-and-water way of mixing paint.) The subject of the two pictures might be the same, but they would look quite different.

Artists have used the oddest things to paint or draw with, and to paint or draw on. There was a French artist who had the habit of drawing with a quid of tobacco he took out of his mouth. Some artists in the 1990s have experimented with milk. The English artist Augustus John (1878–1961) dashed off a portrait of a friend on a tablecloth – now it is displayed in the British Museum in London. And many artists have used junk – as Picasso did when he made a bull's head out of a bicycle saddle and handlebars.

Before paper was invented, people used other things to draw or paint on. The Ancient Egyptians used papyrus (made from a kind of grass), wood, or clay – see the painting on page 47. In the Middle Ages and at the time of the Renaissance, painters used prepared wood (as Sassetta did in his painting on page 34). The medieval Books of Hours, like *Les Très Riches Heures du Duc de Berry* (page 63), were made of vellum (from calfskin). The Japanese and Chinese had a tradition (which still continues) of painting on silk. The Australian Aborigines often painted on bark, since that was easily to hand.

David Kemp was asked to make a piece of sculpture for a special exhibition for children in London, called *The Art Machine* – and this is what he made. He saw the possibilities in two old boats, just as Picasso saw the possibilities in parts of an old bicycle. ▶

Our hands are the most basic tools we have for art. A boy in Peru made this picture just with his hands and paint. He chose the colours well. ▼

◀ Michelangelo, who was working in Italy about 500 years ago, liked to use marble for his sculpture. Many of his sculptures showed exactly how he worked on the marble, how he cut out the rough shape, how he used a big chisel for the background and a fine chisel for bodies, and how he polished some parts, like the faces, very smooth.

Drawing

Artists use drawing – with charcoal, chalk, pencil, or pen – for three main purposes. The first is as part of their training. The second is for keeping a sketchbook, like a private diary, of everything they think might come in useful. And the third is to create a picture in its own right – for other people to look at.

Learning to look – through drawing

Artists from Dürer in the 16th century to Henry Moore in the 20th century have spent a good deal of their time making drawings. The sort of thing that Dürer found useful was to dig up a piece of turf, bring it into his workshop, and then draw it from many different angles. Moore used to make countless drawings of an elephant's skull, or of sheep in the different seasons, of Stonehenge, of pebbles . . .

 In the European art schools of the 19th century, drawing was the most important subject. Students started off by drawing copies of engravings (which were already copies of other pictures). Then they moved on to making drawings of plastercast copies of Greek and Roman statues. A student was not allowed to pick up a brush to paint, or to make a model for sculpture, until he or she (and it was nearly always he) had thoroughly mastered drawing. And even then students made copies of other works, paintings, and sculpture.

In the 1960s the art schools more or less stopped teaching drawing. But then, 20 years later, people began to realize what they were missing. Students were not being taught how to *look* – which is what drawing does for you.

Then artists like David Hockney (1937–) started to say what a good thing copying was, as it was a first-rate way to learn to *look*, because you were made to look through somebody else's eyes. People started to listen – to him and to others. Nowadays drawing is back in the art schools.

Never without a sketchbook

Artists, like writers, often need to jot down ideas, record things they've noticed, note down ways of solving problems they're working on. Artists' sketchbooks are fascinating to look at – partly for the way all sorts of unlikely things jostle together. We feel we are being let in on the ways artists set about their work, and allowed to see their private reactions to things. We are lucky that the sketchbooks or notebooks of many well-known artists still exist.

Leonardo da Vinci was brimming over with ideas on all sorts of subjects, and filled many albums with drawings and notes. There are sheets of drawings of observations of the natural world – of how water flows, of studies of the structure of a bird's wing, of plans for a flying machine (remember, it was 500 years ago), of hair, of a child in the womb, of details of buildings, and so on. Leonardo was left-handed, which you can see from the direction of the lines in his drawings.

Dürer kept a day-to-day picture diary of people and places, when he made a journey from Nuremberg to the court of the Emperor Charles V in the Netherlands, to ask for his pension to be renewed. (He got the pension, and we still have his diary.)

Perhaps the biggest collection of artist's sketchbooks that we have are those made by the English landscape artist, J. M. W. Turner (1775–1851). Turner was fascinated by light and its effect on colour. His sketchbooks are full of tiny watercolours (lovely in themselves), with thumbnail drawings of clouds, and notes to remind him of the colours. He once had himself lashed to the mast of a ship in a storm so that he could see the effect of the light on the water. (He must have had a waterproof sketchbook that day . . .)

Drawings for others to see

Many artists have enjoyed drawing so much and found it such a good medium, especially for showing people's characters, that they have looked on their drawings as complete pictures. Look back at the drawings by Rubens (of his son) and by Dürer (of his mother) on page 48, and you'll see why.

Here is a page from one of Leonardo's sketchbooks. On it he drew the face of St James, one of the figures that he put in his famous painting *The Last Supper,* and in the corner of the page a sketch for part of a castle.

Drawing of a girl by Gwen Darwin, who later became Gwen Raverat .

Fast frescos

Artists not only make small drawings and sketches to prepare for easel paintings and for sculpture, but they also make full-scale drawings on a wall for mural paintings. These are paintings done directly on to a wall (*murus* = Latin for 'wall'). In Crete 3,500 years ago, tombs and palaces were decorated with murals. The Romans used to decorate the rooms of their grand villas with murals about 2,000 years ago.

In Italy in the 14th and 15th centuries, artists also painted murals – in churches, chapels, and government buildings – but using a special technique. These paintings were called frescos (*fresco* = Italian for 'fresh, wet') because the paint had to be put on while the plaster was still wet. Painting a fresco must have been very exciting work. The wall to be covered might be 20 metres long and 7 metres high, or even bigger. And there might be two, three, or four walls to be painted. So artists had the chance to make a very big and bold design. They had to work fast and not make mistakes.

▲ Here is a rather rare picture (from a 15th-century book) of a girl sketching the design of a fresco. Women did paint in the workshops and studios of their artist fathers or husbands. But they were not named.

This woodcut (from about 1500) shows a fresco painter in a rather dramatic situation. The devil is pulling him off the scaffolding, but he is saved by the Virgin Mary. She steps out of the fresco to catch him by the hand. People at that time believed in the power of religious pictures. Notice the painter's equipment beside him which includes a T-square, paint, pots, and brushes. ▶

◀ This is part of an enormous fresco called *The Legend of the True Cross*, in a church in Italy. It is by Piero della Francesca (1420–1492). This part shows 'The Dream of Constantine'. He painted it in sections as shown on the right. Because the artist was painting on wet plaster, he could only do a small part at a time.

Piero was very interested in perspective. He worked out a complicated scheme based on geometry. When you have read the next two pages, see if you can work out some of the ways he leads your eye into the picture.

Piero della Francesca, 'The Dream of Constantine', about 1460, fresco in the Church of San Francesco, Arezzo.

Perspective – a way of showing the real world

Perspective is *one* way of looking at the three-dimensional world and showing it in two dimensions. But it's not the only way of doing this. It's been particularly important for artists in the Western world for the last 600 years or so. But artists did without perspective for thousands of years, and many do so now.

There are several examples of artists using perspective in the pictures in this book. There are a couple of important points to understand about perspective.

1 The further away things are from you, the smaller they look

Look again at the photograph of the girl on page 5. The reason you knew the little man was not dancing on her finger, but was on the far side of the field, was because he looked so small. You already knew from your experience of looking at pictures that things in the distance look smaller than things near to. (This is true, even though the thing in the distance may *really* be bigger than the thing near to.) When artists want to show a scene in a 'real' way – to make it look the way we see it – they also do this.

Look at the sketch of the painting by Mary Cassatt on this page. The biggest thing in the picture is the boatman – because he's nearest to us. The next biggest is the woman with the child on her lap – they are further away, at the far end of the boat. Right away in the distance, on the far shore, we see some houses. They look tiny – smaller than the boatman's ear. We know that real houses are bigger than ears. But because we know things in the distance look smaller, we just think to ourselves, 'The lake must be quite big and those houses must be a long way off.'

2 Lines lead the eye into the distance

Look at the diagrams above right. Imagine they are floorboards. Look at Diagram A. You're standing in the

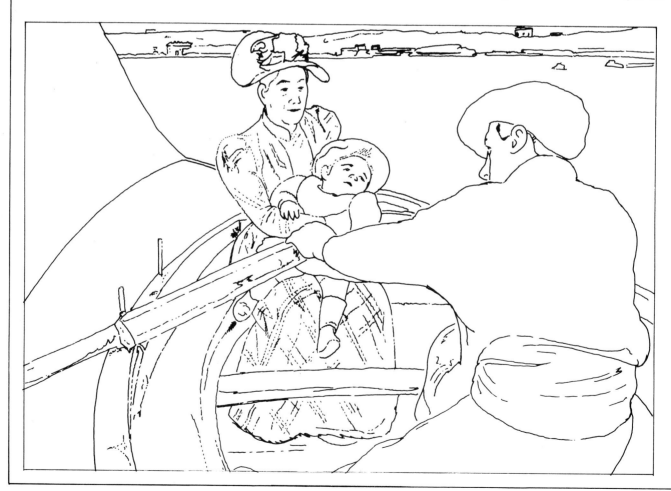

A B C

middle of the room, and the floorboards are coming together and disappearing into the distance to a point on a line we call the 'horizon'. That point is level with your eyes. In Diagrams B and C you are standing first on the left and then on the right. In each diagram the

floorboards go to a different point in the distance on the horizon.

Now look at the sketch of the *Sunday Afternoon* painting on this page. Look for the lines of the river bank, the people, and the trees. Your eye is led to a certain point in the distance, on the horizon. This gives

you an idea of how artists can compose their pictures to make you see things and people at different distances away, even though the surface of the picture is flat. It is in two dimensions. But the scene appears in three dimensions – it has depth.

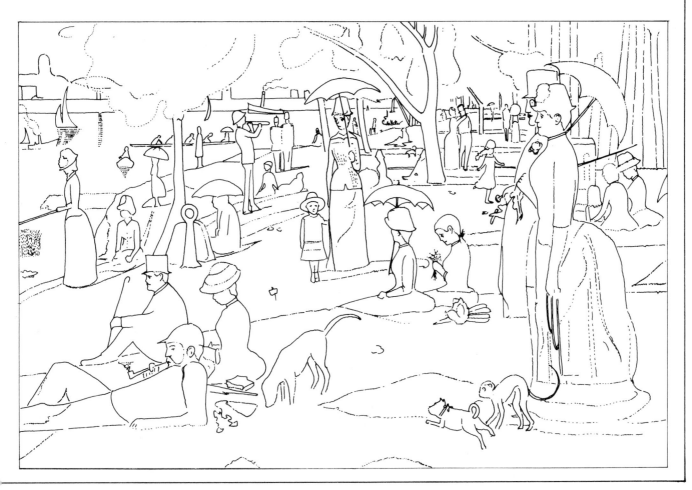

Working in a studio

Although artists were employed in painting whole walls or ceilings, a large number of paintings, even altarpieces for churches, were much smaller and painted in a workshop or studio. Artists in the past had many assistants to help them. But by the 19th century it was usual for an artist to work alone in a studio. The studio might be only a cold little garret. Or it might be a specially built studio, with big windows to let in light from the north, and with equipment such as easels, racks for storing canvases, a platform for a model to pose on. Some 19th-century studios were quite luxurious. They were places where the successful artist would not only paint but would also entertain friends and patrons.

Here is a 15th-century woman artist painting a picture on an easel. She seems to be looking at herself in a mirror, but the picture she is painting is not a self-portrait. She has her pots of pigment on the table by her side. The stick she is using to support her right hand is exactly the same as those artists use today. ▶

About 1470, manuscript on vellum.

▲ In Dürer's workshop he had a rather complicated drawing frame to help him with perspective. It consisted of a movable eyepiece and a piece of glass in a frame on which the artist could trace the outline of what he wanted to paint.

▲ A 19th-century artist's studio.

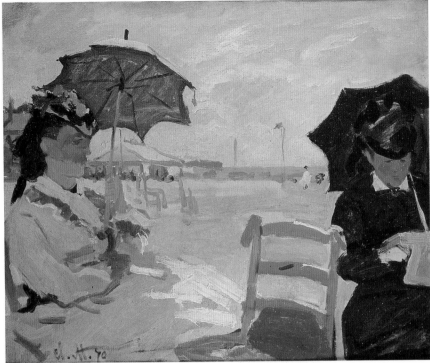

Claude Monet, 'The Beach at Trouville', 1870, oil on canvas, 38 x 46 cm.

Working in the open air

Ever since artists had taken to painting pictures of landscapes, in the 18th century, they had made sketches on the spot, out of doors. But it didn't occur to them to paint the final picture itself out of doors. What you did out of doors was the raw material for your painting. 'Proper' painting was something you did in your studio, with all your paints and equipment at hand.

But when the Impressionist painters began to experiment with colour and ways to show light, they found they wanted to work out of doors. It wasn't just a question of the light. They felt that somehow work done out of doors was more 'honest' and 'true'. They could observe nature closely, and catch the quickly changing effects of the weather.

It became the fashion to work that way, and to use lightweight equipment that could be folded up and easily carried around. The new paints, based on chemicals instead of natural pigments, were in tubes, and convenient to pack. But many of the Impressionists took their paintings back to their studios to finish them off. Monet said he never had a proper studio. He used a boat. Later, when he lived in the country at Giverny, he had a room that served both as studio and sitting room.

To us it no longer seems unusual to work out of doors. In fact some modern artists have worked under very extreme weather conditions. The Scottish artist, Joan Eardley (1921–1963), who lived on the very windy east coast of Scotland, used to weight her canvas down with stones, so that it wouldn't blow away!

This oil painting by Claude Monet (1840–1926), *The Beach at Trouville*, really was painted on the beach. He was spending a holiday in Trouville with his wife Camille (on the left) and their small son, Jean. The woman in the black dress may be Madame Boudin, the wife of Eugène Boudin, a painter friend. Perhaps the little red beach shoe on the chair belongs to Jean.

This photograph (much magnified) of a detail of the painting shows sand from the beach stuck in the paint, blown there by the wind.

This painting by Edouard Manet (1832–1883) shows Monet in his boat, set up as an outdoor studio.

Edouard Manet, 'Monet Working in his Boat', 1874, 80x 98 cm.

Computer art

Today people are experimenting with computers in making pictures. Using a 'painting' software program, you can 'paint' a picture directly on the screen, trying colours out, moving shapes about, enlarging and reducing them. Then you can print the picture you have produced, or you can use this plan as a basis for a picture, which you can draw or paint in the usual way.

You can also make the computer produce repeated shapes and patterns which build up into a picture. This is called computer-generated art. And of course it can be sent (electronically) to other computer users.

Designers of books and TV graphics, architects, and engineers also find a computer a wonderful tool to help in their work. The great advantage is, that shapes and lines can be moved round with great speed and precision many times over.

If you haven't yet tried out one of the computer painting or graphics programs, it's worth finding someone who will let you use one. The speed and freedom to experiment are exciting. The computer, as a tool in art, seems a very long way from Dürer's drawing frame.

This is a picture made by the artist Deirdre Borlase using a computer program. First she printed it straight off the computer. Then she tried photographing it from the computer screen and copying the photograph on a colour photocopier. The second way, shown above, gave a better result.

Today many artists have started to use computers – both to help them plan the composition of a picture, and also actually to 'paint' the picture. Here is part of a computer graphics program. The signs on the left are the 'icons' that tell you what computer 'tools' you can use.

9 Artists earning their living

Poor as a church mouse? Rich as a business tycoon? Artists have been both – and still are. Mostly they have been something in between. But in many parts of the world artists have not been thought of as people who 'earned their living' at all. No-one in their own tribes thought of paying the shaman who made a mask for a ritual dance, or the African carver who made a wooden head, or the Aborigine making a bark painting. They were thought of as 'special' members of their group because they made sacred art. They were either supported by the group, or did ordinary work, such as hunting, as well. Where art is sacred, artists are sacred. They weren't doing a job, in our modern sense, at all.

This tiny picture of a Greek sculptor working on a head is carved on a gemstone.

About 200 BC, carnelian ring stone, 1.3 x 1.5 cm.

Earning their living the hard way

When we look at some of the Greek statues, carvings, and pots that still exist, they are so marvellous that we can't help thinking that the people who made them must have been honoured and respected. But it wasn't always so. The rich Greeks who lived in Athens about 2,500 years ago, and talked endlessly about politics and philosophy, were snobs when it came to artists. They thought of artists as rather low-level workers, engaged in dusty and dirty jobs – chipping away at stone, sweating it out in metal foundries. These men were just working for their living.

Over the next century things changed in Athens. Architects and sculptors came to be treated much more as equals by those who employed them to plan temples and make statues of the gods. They were no longer just workmen, but became respected artists whose names have come down to us today. Phidias, who is thought to have supervised the sculpture of the Parthenon in Athens, was one of the best known. The strange thing is that not one of his own works still exists today – we only know his work through descriptions, and copies made by the Romans.

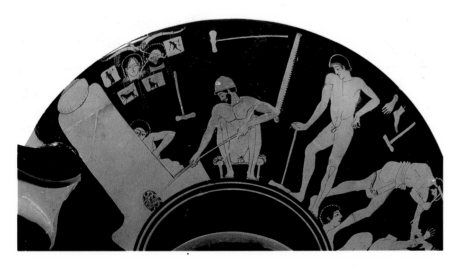

This picture of an Ancient Greek bronze foundry, with sketches on the wall, is from a Greek bowl (made in about 480 BC) shaped like the one below.

This 13th-century Benedictine monk is painting a statue of the Virgin and Child. He is holding in his left hand a dish of paint, and the rest of his tools are on the floor. The picture comes from a religious book made for Lady Eleanor de Quincy. Now it is in the Library of the Archbishop of Canterbury, in London.

About 1260, vellum, 27 x 20 cm.

Working for religion

Much of the art of the Middle Ages was made by monks working in monasteries. Some monks were given the tasks of farming, looking after the fishponds, and making honey. Others were given the work of copying manuscripts and illustrating them with illuminations. We don't know the names of most of these artist monks, but it is possible to recognize the style of one illuminator or another across a number of manuscripts. The Books of Hours and other religious books that they worked on were sometimes specially commissioned as engagement or wedding presents.

Not all the makers of religious books were monks – some were what were called 'lay scribes'. These were ordinary people just working in the monastery.

Women artists

Although we hear mainly about men, there were women artists too. We even know some of their names. There was, for example, Mabel of Bury St Edmunds, in the East of England, a well-known embroiderer who worked at the royal court between 1239 and 1244. We have records of two women in London in the 14th century, a gilder called Dyonisia La Longe, and a weaver called Matilda Weston, who combined their crafts with running alehouses. There was another Matilda, widow of John Myms, who in her will left all her materials for making pictures to her apprentice, William. So she must have been quite a successful painter.

But on the whole women at that time worked not as artists in their own right but as members of a family business. They either did the hard work as assistants, such as carrying heavy materials or doing the plastering, or, if they were of a higher class, they helped manage the business affairs of their husbands. There are many records of women taking over the workshop of a goldsmith or weaver husband when he died.

Here is a miniature of a woman painting another statue of the Virgin and Child, about 200 years later in France. Look carefully at the bench on which she has laid her tools and paints. Those small things nearest to you that look rather like seashells are in fact just that – oyster shells. Painters used them as cheap palettes for their paint.

Working for a patron

During the Middle Ages in Europe, the Christian Church was the great patron. Work might also be commissioned by a king or queen, by a noble lord or lady, but this too was mostly for a religious purpose.

By the 15th century, at the time of the Renaissance, there was a wider range of people who commissioned works of art. Many wealthy rulers liked to have artists attached to their court to design whatever needed designing – palaces, chapels, frescos, fountains, furniture such as wedding chests, jewellery – to whom they paid a salary. Rich bankers and merchants also commissioned artists to produce small stone and terracotta sculptures, to design marble floors, to paint religious pictures, to produce gold and silver objects for their homes. People liked to show off their wealth. So there was an enormous demand for works of art of all kinds. You have to remember that there was no 'mass production' in the sense that we know it, at that time – things were made individually.

There were large numbers of painters, sculptors, and goldsmiths to feed the demand. At the beginning of the 15th century there were, for example, about 100 painters earning their living in Siena, a small city in Tuscany (Italy) of about 25,000 inhabitants. That is one painter to about every 250 people.

Artists as craftspeople

Being an artist in the 14th and 15th centuries – like being a carpenter or a tailor or a butcher – often ran in families. It was common for artists to marry into other artists' families, and in this way family businesses were built up. Take the Bellini family of artists, in Venice, as an example. Jacopo Bellini (1400–1470) left his sketchbooks in his will to his son Gentile (about 1429–1507), also a painter. When he died, he left them to his brother, Giovanni (about 1430–1516), who became the most famous painter of the Bellini family. Those sketchbooks were part of the property of their art business. Father and sons even had a kind of family trademark that they put on their works. And Jacopo's daughter married the painter Andrea Mantegna (1430–1506), making it even more of a family of painters!

Art was very much a business. Artists were not thought of as people expressing themselves or their feelings about the world. They were seen as craftspeople with particular skills, taking on work from the Church, dukes and princes, the government of a city, and from private patrons, such as rich bankers and merchants. They were in it as a trade for profit, to earn a living. They were not even called 'artists', but painters or sculptors and so on, according to what they specialized in.

It was the family who decided what occupation the children should follow. People believed that, with proper training, anyone could become a reasonably good artist. So a boy was put to work, as an apprentice, in the workshop of a painter, sculptor, or goldsmith.

This cutaway painting of a building (a miniature from the North of Italy made in about 1450) shows different craftsmen at work. Armourers, clockmakers, a scribe, an organ-maker, a painter, a goldsmith, and a sculptor are all at work in similar shops. ▶

Guilds

When a young artist had gained a good deal of experience, he hoped to be accepted by a guild. The guilds were in some ways like trade unions. An artist could not get important commissions unless he belonged to a guild. The guilds helped their members by giving them a qualification, sorting out disagreements between them and patrons over commissions, and probably giving money when an artist fell on hard times. Sculptors often belonged to the same guild as stonemasons and carpenters. Painters sometimes belonged to the pharmacists' guild, because they bought their colours from pharmacists. The powerful and rich guilds often acted as patrons themselves.

Prints and reproductions

With our printed books and magazines, our TV programmes and films, our photocopies and faxes, it is very easy today to send images and messages not only from one person to another but also from one country to another. But 500 years ago the only way to send a message was to send it by a messenger. The only pictures you saw were those immediately around you in your local church, convent, monastery, castle, town hall, or big house. If you wanted to see work by a particular artist who lived somewhere else, you had to travel there to see it. There were no art galleries, no handy postcard reproductions. Artists, or their assistants, sometimes made a copy of a painting to be sent to another patron, or to keep for themselves – so then there would at least be two places in which it could be seen. And of course artists painted many different versions of the same picture – the Madonna and the Child, for example – to meet the wishes of the patrons.

But in the 15th century a technique (invented 600 years earlier by the Chinese) started to become important in Europe. It was the woodcut, and it became part of the printing revolution. For the first time it was possible to make several copies of one picture in black and white. It could be 're-produced' – that is, made more than once. So more people could see it. The development of the woodcut, engraving and other forms of prints enabled copies of artists' work to travel from country to country.

Prints and their uses

The point about prints is that they give artists another range of techniques for producing works of art, and also more ways of earning their living. And they bring works of art to many more people.

There are two kinds of prints. The first kind is an image printed from a block or plate prepared by the artist, and printed by the artist or under the artist's supervision. The second kind is what we call mechanical reproduction, which is done by a photographic method. That is the kind of print you get on a postcard. People argue about the effect mechanical reproduction of works of art has on us. It has been reproduced in a different size and on different material, and the colours are often not at all accurate.

Making prints

Woodcuts

The technique is to cut out a picture *along the grain* of a block of wood. Then you ink the raised surface of the image and print it. (It is the same technique as you can use with a potato or with lino, as in the linocut (**1**) of the old village pump in the

village of Coton near Cambridge. It was made as part of a local school project. Woodcut (**2**) was made in 1568 by Jost Amman, and is interesting because it shows an artist actually making a woodcut. (**3**) is a woodcut by the 20th-century

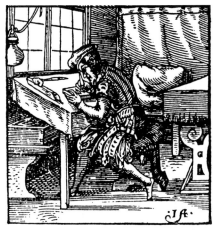

3

Japanese printmaker Shiko Munakata (1903–1974) called *The Journey North*.

Wood engravings

These are like woodcuts, but only hard wood is used and the picture is cut out *across the grain* of the wood. In this century artists have taken up wood engraving again, for illustrating books and for making prints as pictures in their own right. Gwen Raverat's wood engraving called *Fool's Song* (**4**), is an illustration for a children's book.

4

Line engravings

The artist draws his design on to a metal (usually copper) plate with a tool called a burin – a short steel rod with a sharp point. (The picture on page 103 is an example.) Artists started to use this technique in Italy and in Germany at about the same time – in the middle of the 15th century. From this time until the 19th century that was the main way of reproducing artists' work, and this was how their work became more widely known. It was also a useful extra way for artists to earn money.

Etchings

This technique was invented in the 16th century. It can produce more varied effects than engraving. You take a metal plate and coat it with wax. You draw your picture on the wax with an etching needle. Then you put the plate in a bath of acid. Where the etching needle has scratched through to the metal, the acid bites into the metal. Then you take the plate out, get rid of the wax, ink the plate and wipe it. This means that it is the inked lines that print (not the rest). Perhaps the greatest etcher ever was Rembrandt.

Today many artists find they can create interesting effects through etching (sometimes using more than

5

one plate for the same picture). Because a number of copies can be printed from the same plate, they can be sold at lower prices than 'one-off' pictures. The etching above, *The Sculptor* (**5**), is by Thomas Newbolt.

6

Lithographs

The word comes from the Greek word *lithos*, meaning 'stone'. The technique was invented at the end of the 18th century. You draw on a special kind of stone (nowadays a metal plate is sometimes used instead) with a greasy crayon. This drawing is then 'fixed' with a chemical, the stone is wetted and oily ink rolled over it. The ink sticks to the greasy crayon parts, but not to the rest. Then, using damp paper, you take a print from the stone (or plate). Goya was one of the first artists to experiment with this technique. In the 19th and 20th centuries many artists have used it. Honoré Daumier (1808–1879) produced most of his cartoons as lithographs (**6**).

Artists at court

Today kings, queens, presidents, and prime ministers are not very interested in commissioning works of art. Sometimes the government commissions a splendid new opera house, or a new art gallery or arts centre – but these are all *buildings*. In North America and many European countries there is a scheme called 'Per Cent for Art'. This means that anyone putting up a new building must spend, say, 1% of the building costs on works of art, inside or outside the building. This is one way not only for governments but also for businesses and industrial firms to act as patrons of art. And there are schemes that allow owners of very valuable paintings to pay less tax on them, if they sell them, or leave them in their will, to national museums.

In the past, in Europe, such schemes were not necessary. Not only kings and queens but princes, dukes, and even popes had their own 'courts' round them. Many were keen on commissioning artists, sometimes paying them to be 'resident artists' at court.

Some artists travelled quite far afield to get commissions. Usually it was the most famous, 'modern', and revolutionary ones who were invited to distant places. The Italian Leonardo, for example, worked in the main art centres of his own country, before moving to the court of the King of France. The Flemish painter Rubens moved between Germany and Antwerp, in the Netherlands, then worked in Italy for various patrons, and visited Spain and England (where he was knighted), before moving back to Antwerp as official court painter. Portrait painters – such as Holbein and Titian – were in demand in many different countries. But most artists worked locally. Transport and communication were very slow. It was far more difficult then for artists to hear about what new things were going on in art – even in their own country, never mind abroad.

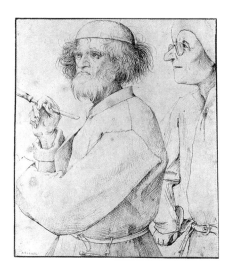

This amusing drawing, made in about 1565 by Bruegel the Elder, tells us a lot about what the artist (on the left) thought of the buyer of his picture. 'You fool!' he seems to be muttering under his breath.

Battle with the art 'pirates'

Artists in the 18th century benefited a lot from the invention of engraving. The English artist William Hogarth (1697–1764) started out as an engraver, making book illustrations, and studied painting in his spare time. He married his teacher's daughter, and made a name for himself as a painter (look back at *The Shrimp Girl* on page 52). He made several series of paintings on such subjects as marriage, making fun of people's habits and criticizing social conditions. He then had engravings made from his paintings, and these were enormously popular with people of all classes. Many of them were reproduced illegally – without paying Hogarth any money – by 'pirates'. Hogarth had a great battle with the pirates, and eventually Parliament passed the Copyright Act, which protected artists' and writers' rights.

Exhibitions

Hogarth also started an academy for teaching art, and this was the forerunner of the Royal Academy.

The Royal Academy of Arts in London was founded in 1768 by Sir Joshua Reynolds and others, including the artist Angelica Kauffman. It housed an art collection, ran an art school (which still exists today), and held a big art exhibition every year, a very popular and fashionable event, which still takes place every summer. This gave a great new opportunity for living artists to show their work.

P. A. Martini,'The Exhibition at the RA in1787', 1787, 32 x 49 cm.

Palaces of art

The art collections made by the royal families of Europe were private. But the French Revolution in 1789 changed all that – at least in France. The works of art belonging to the royal family and to other aristocratic families were taken over by the new government. From now on these works of art were to be for 'the people'. Artists, too, began to paint not for the aristocrats and royalty but 'for the people'. So in 1793 the first real 'people's art museum' came into being, later known as the Louvre.

A little later, the various states that made up Germany started to found public museums that included paintings, drawings, and sculpture. But the people who set these up thought of them as 'palaces of art', or 'temples of art'. They thought they ought to have an atmosphere of silence and 'sacred solemnity' – very different from the down-to-earth atmosphere surrounding the craftsmen-artists of the Renaissance.

This engraving of the 1787 Royal Academy exhibition by P. A. Martini gives a good idea of how they used to hang paintings then, covering every square inch of wall. The President of the Royal Academy, Sir Joshua Reynolds, is showing the Prince Regent round. It looks an enjoyable event – even for children and dogs.

Opportunities for living artists

By the 1830s, museums and departments of museums were being set up which were of more practical help to living artists. Across Europe, 14 cities had set up museums showing only modern art, and another 66 cities had included galleries of modern art in general museums.

The 'new rich' in Europe, the men who were successful in business and industry, were much more interested in buying works of art from living artists than in tracking down Old Masters to buy.

Meanwhile in the USA, after the Civil War, New York was 'bustling rich', as they said. A number of New Yorkers decided that what the city needed was a museum that would have something of everything – the complete range of the world's treasures. It was to be for 'the popular instruction and recreation' of the people. Set up in 1870, the Metropolitan Museum was straight away enormously popular with the people of New York. By 1894 they had demanded a restaurant (rare in a museum in those days) and somewhere to park their bicycles. Although the museum was more concerned with making collections of art from the past, it also bought work from living artists.

Art becomes big business

By the second half of the 19th century it was the ambition of many successful businessmen to own a collection of paintings by living artists. By this time art dealers had established themselves. Many had galleries of their own, which became fashionable meeting places. These had developed from shops that supplied artists' materials.

Richard Redgrave (1804–1888) was a popular artist with the Victorians. He liked painting pictures that told a story, like this one called *The Governess*. What could have been in that letter to make her so sad? The girls skipping, in their pretty dresses, are in great contrast to her dark figure. But the girl with the book has a more thoughtful look – perhaps she realizes something is wrong.

Richard Redgrave, 'The Governess', 1844, oil on canvas, 71 x 92 cm.

Of course the success of the dealers depended on the artists whose work they showed. Victorian artists particularly liked painting scenes with a story behind them – the return of the soldier, the couple leaving England on an emigrant ship, the faithful sheepdog at his master's deathbed. The originals sold for large sums. Some of them were reproduced as prints and sold in thousands. The happy result was that many of the artists who painted them earned a lot of money. No more cold garrets for them, but grand houses and spacious studios. You can still visit one of them in London – Leighton House. It belonged to Frederic Leighton (1830–1896), painter, book illustrator, and sculptor, who became the President of the Royal Academy and was the first English artist ever to be made a lord.

The great collectors

It has been fortunate for the world that in the last hundred years some of the richest people, especially in America, have chosen to spend a good deal of their money – made in steel and oil and other industries – on art. The collections of men like Paul Mellon and Henry Clay Frick started off as private collections and ended up as public ones. These men simply gave them to the nation. Some also gave the houses in which they hung. The collectors of modern art gave a great boost to the art market.

The collector who has made the biggest mark on the art world in the second half of the 20th century is J. Paul Getty II. He left so much money for art that it has been quite a problem to spend it. There is the Getty Museum in California, with its collection of painting and sculpture, which is being added to all the time. Then there is a Foundation for helping scholars of art history, and art education.

Many of the other great collectors in the 20th century have been Japanese. They are willing to pay very high prices for pictures – particularly by the Impressionists. Unfortunately many of these paintings are never put on view for people to enjoy, but are kept at the bank for safety. The highest price ever paid for a painting was US$82.5 million (£48 million) in 1990, for *Portrait of Doctor Gachet* by Van Gogh. Another painting by Van Gogh, *Irises*, was bought by the Australian business tycoon Alan Bond in 1987 for US$53.9 million (£31 million).

The extraordinary prices that have been paid for paintings at auctions in recent years have made people ask all over again what decides the value of something. The people who benefit from these high prices are usually not living artists. When Van Gogh was alive, he found it very difficult to sell anything at all. It is the art dealers and the art auction houses that make the money out of artists who are now dead.

What makes something precious?

Pieter Wiersma was born in Holland, and remembers as a child of 3 or 4 always playing with mud – making models of the canals and dykes he saw around him. He used to come home with sopping wet feet, and his mother scolded him. When he grew up, he was fascinated by sand and water, and started to build the most extraordinary castles out of sand. He builds them below the high-tide line and knows the sea will soon wash them away. Sometimes he spends the night on the beach with the castle he has built. He photographs his castles before they disappear.

This castle is the 93rd that he built (in 1980). It was already surrounded by water when he took this photograph.

People used to think that what made a work of art precious was partly what it was made of. In Ancient Greece sculptors used the finest marble for their statues, decorated them with gold, and used precious stones for their eyes. In Italy 500 years ago large areas of religious paintings were covered in gold. The colour used for the blue of the Virgin Mary's cloak, for example, was made out of a precious stone, lapis lazuli, ground down to a powder. In Russia, the cover of an icon (a religious picture of saints) was made of gold or silver and often studded with gems.

People wanted their works of art to be made of precious materials, as many of them were for religious use – to put in temples, shrines, and churches. People thought the more precious they were, the more they honoured God. Although that idea is no longer so important, some people still find it difficult to swallow the idea that a pile of ordinary bricks, arranged in a certain way, can be a real work of art.

Nobody in the Middle Ages would have thought a statue made out of old nails, however well done, worth anything at all. A painting in a plain wooden frame, however good the painting, would have looked cheap to most people even a hundred years ago. Of course people did value a painting or a sculpture also for the artist's reputation, if he or she was well known and in demand. Nowadays we think that it is only the skill of the artist, and his or her reputation, that make the value of a work of art.

Here today, gone tomorrow

In 1990 the artist David Hockney sent a big picture from the USA to a friend in England by a fax machine – in 48 sections! Lines on fax paper fade. But Hockney made sure that his friend's machine could take special paper that did not fade.

Artists like Goldsworthy think of their creations as parts of nature – which disappear or wear away. Buddhists make beautiful and complicated patterns out of coloured sand, and then sweep them away.

Art galleries and museums spend a lot of time and money on restoring paintings and other works of art.

How long do we expect art to last?

*'A lily of a day
Is fairer far, in May,
Although it fall and die that
 night,
It was the plant and flower of
 light.'*

The English poet Ben Jonson wrote that. Do you think it might be true of art as well?

Faking it – is it a crime?

Because of the value we place on an artist's name, fakes have also become valuable. You have to remember that a work is only a fake if the artist tries to pass it off as somebody else's work. Copies are not necessarily fakes. Artists who produce fakes do so for a number of reasons. The obvious reason is to make money. But another one is the sheer pleasure of taking in the experts. Some fakers are extraordinarily skilful. They not only match the style of the artist they're copying, but they also manage to make a painting look genuine through using paper, canvas, or wood of the right period, and treating the surface of the painting to make it look the right age. People always enjoy seeing experts fooled, so the public usually feel sympathy with the faker. You then get an odd situation. Fakes are valuable when they are thought to be famous artist, but once everyone knows they're fakes, they're valuable in a different way – as fakes.

Andy Goldsworthy is an English artist who often makes sculptures *not* to last. He makes beautiful forms out of leaves and flowers, roots and mud. He has been to the North Pole and made fantastic sculptures out of snow and ice. All that is left of these sculptures are the photographs he took of them. If you have the chance, next time it snows make a snow sculpture instead of a snowman – and take a photograph of it, as Andy did with his North Pole sculptures.

Here is a photograph of one of his works that Andy has chosen for this book. He made it in Australia in 1992 out of kangaroo and sheep bones.

10 A horse is a horse . . . ?

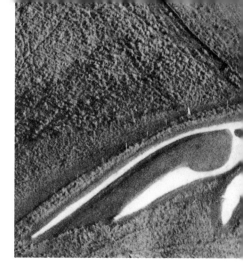

Why are no two works of art the same? There is a simple answer to that question. In the world today there are about 5,400,000,000 people. Each of those people is different from everyone else. Everybody (apart from identical twins) looks and behaves differently. And each person's brain has millions and millions of nerve cells, arranged into billions of tiny electrical circuits. These electrical circuits are all different in different people – and they carry messages. The nerve messages are what produce creative thoughts. If you think about that, you'll get some idea of the reasons for the enormous variety of works of art.

Learning from others and being original

Even though people and what they produce vary so enormously, artists are always learning from the work of other artists. Today it seems very important for an artist to be 'original' if he or she is to become well known. In the past it was not always like that. As you've read in the last two chapters, artists from the time of the Ancient Egyptians and Greeks until the 18th century in Europe learned their art and craft in the workshops and studios of other, established artists. Also artists were often given detailed instructions about what kind of work of art they were expected to produce for a patron or a customer. Only a very few artists experimented and struck out in new ways. Some of these we think of as 'geniuses'. But now *everyone* is expected to be doing his or her 'own thing', to be original. At the same time, we know that anyone who produces art must be influenced by the art that has gone before, if not following it then reacting against it. No-one works in a vacuum.

Different ways of seeing

At the beginning of this book, you were asked to think about the different way in which we see things. That meant everyone, artists included. What we see depends on who we are. And that depends on where we find ourselves, in time and place, and even how we are physically (short, tall, short-sighted, long-sighted, etc.), and perhaps whether we are male or female.

A string of horses

On the following pages you can see how people have seen and shown horses. The time between the oldest and the most recent is about 2,000 years. It's interesting to see how horses have been used in different art forms to express a variety of feelings.

Why horses?

Horses are an interesting shape and have a powerful effect on people. They have been linked with the stars (Pegasus, the winged horse, is a constellation of stars), and with gods and goddesses. They have been the animals that have carried soldiers into battle, a means of transport, and great sporting animals. They also appeal to our imagination in a very special way.

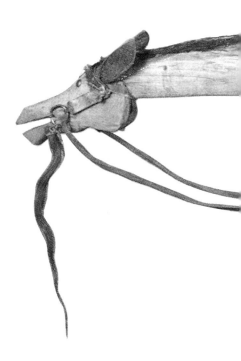

Superhorse

The white horse is the biggest horse in the book. In fact it's the biggest horse in Britain – 111 metres from ear to tail. You can see it in Berkshire, in the South of England, and it's best seen from the air (as in the photograph). But the Celtic people who made it just over 2,000 years ago could never have seen it from the air, of course. So why did these people cut the shape of an enormous horse out of the green turf of the hillside, exposing the white, chalky earth? It's cleaned every 7 years, to keep it white, so it must have been 'groomed' about 300 times! We don't really know why it was made, but it may have had something to do with people's religious beliefs. If you make a cut-out horse, then you can't show any detail. You have to be able to recognize it as a horse from its shape alone. Try making a cut-out horse yourself out of paper or card, and you'll see the problem.

Sioux horse

The galloping horse was made by the Sioux Native American people, out of wood, leather, and real horse hair. There can never have been a horse so long and thin, and yet we recognize it immediately as a horse. What it gives us is the feeling of speed. Perhaps this horse is more speed than horse, in the same way as some faces in Chapter 5 were described as 'more feeling than face'. Historians think this is a *wounded* horse. Why make a carving of a wounded horse? When the Sioux people celebrated a victory, they danced, praising not only the warriors but also the horses that had been wounded in the fight. This carving of a horse may have been used in a victory dance.

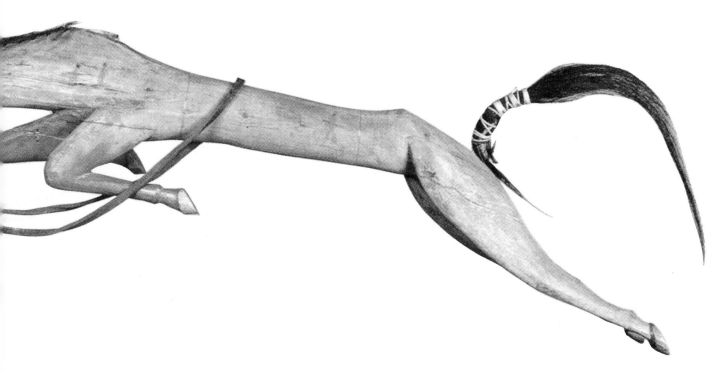

The battle of the rocking horses

The horses in *The Battle of San Romano* by Paolo Uccello (about 1396–1475), with their gay colours and perfect grooming, look more like rocking horses than battle horses. Uccello was one of the first painters in Italy to become interested in perspective. In fact he was so fascinated by it that he stayed up to all hours working at it. The story goes that, when his wife called him to bed, he'd just murmur, 'What a sweet thing perspective is!'

The picture is really an excuse for working out all sorts of complicated ways of showing perspective. Look at the dead soldier lying on the ground on the left, the lances of the soldiers on horseback, the path winding up the hills into the distance, and the small figures on it. Look back at the special feature on perspective on pages 90–91, and see if you can work out how Uccello tells us about depth and distance in this picture. He has managed to make the horses stand out in a three-dimensional way, like carved and painted animals on a roundabout.

Paulo Uccello, 'The Battle of San Romano', about 1450, painted on wood, 182 x 320 cm.

Horses of the gods

In South India, outside Hindu village temples, you often find large figures of horses. These belong to the gods who protect the village. The horses can be life-size or even bigger, modelled in terracotta and often painted. The two horses shown above are beautifully decorated, with plumes on their heads, ornaments round their necks, decorated cloths on their backs, and special saddles. They look rather like circus horses. The Indian toy horse below is made of bronze, and is decorated in a similar way.

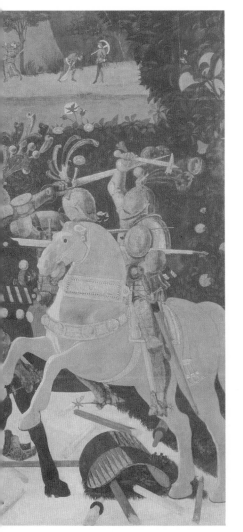

Mystery horse and rider

This horse and rider are one. You don't get the feeling that first the artist drew the horse and then put the rider on it. He saw the two together as one shape. This horse is rather underfed and bony, his tail cut short. He and his rider make a mysterious and attractive pair. Where are they going? It's odd, but somehow we know they're on a journey, not just out for a ride for pleasure. Is it something to do with the wild landscape in the background? Imagine you are being photographed by one of those special cameras that make a map of your eye movements (see Chapter 1). How do your eyes move when you look at the picture for a few moments? Is there one spot, or more than one, that your eyes keep coming back to?

Rembrandt, 'The Polish Rider', about 1657, oil on canvas, 117 x 135 cm.

For years people believed this painting was by Rembrandt. Now some people think it is not by him, but by one of his pupils.

Wild horse head

Elisabeth Frink (1930–1993) had a country childhood with plenty of animals round her, and started to ride when she was 4. Although she made sculptures of human figures and heads, she often came back to animals as a subject – particularly birds, dogs, and horses. She lived for six years in the South of France, where she saw the wild horses that live down by the sea in the Camargue. Her sculpture horses are vivid and horse-like, but not completely realistic. She once said, 'I use anatomy to suit myself.' She made this horse's head in bronze.

63 x 80 cm.

Horse seeks rider

What a different kind of horse from the last one! It's a horse with a human use – look at its saddle and harness. It's standing ready to set off with its rider.

This terracotta horse was made in China, probably about 1,300 years ago. Many horses like this one, some of them glazed in green and yellow, have been found. They are called T'ang horses. The Chinese figures in Chapter 3 will give you a clue to the uses of this horse.

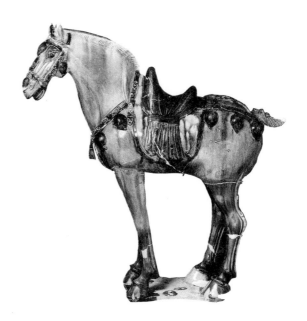

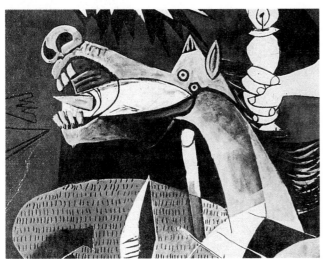

Horse in agony

This horse is part of Picasso's painting *Guernica* (page 38) about the bombing of a town in the Spanish Civil War. There are many images of horror and suffering in that painting, including this horse. It's the kind of horse you might see in a nightmare. It's even like a horse you might see in a comic strip.

In Chapter 5 you were asked to find out, by experiment, which of the features of the human face expressed feelings and emotions most vividly. Try doing the same thing with a horse.

At the Sign of the Black Horse

Many businesses and shops have a sign that they hang outside their shops or offices, and put on their notepaper and publicity material. Lloyds, one of the oldest banks in Britain (with branches in other countries as well), has a black horse as its sign. The sign itself goes back 300 years, to a goldsmith's sign in the City of London. Compare the original shop sign (left) and the present-day sign (above) of the bank, and see what differences there are.

11 Learning the language of art

You probably know what this sign stands for. It is the sign of an organization to do with healing and caring: the Red Cross. (The cross, of course, stands for the Christian religion.) It is a sign that carries a message to those who understand it. In war, it could mean, 'Don't fire on us! We've come to help the wounded.' This kind of sign-with-a-message is called a symbol. Symbols are like a special language, a kind of code that you learn to read.

In art things are often not just themselves but stand for something else as well. The red cross is simple to understand because it is so well known, but symbols in art can be complicated and make pictures puzzling to our eyes. Understanding the symbols can make a picture more interesting and richer to the person looking at it – can make you feel an emotion or teach you a lesson. But what if you don't know the language of these symbols? What do you do?

Learning something about that language is like going to another country and learning some of the language they speak there – you understand more about the people and get more from your stay if you do. In the same way, if you know something about the language of symbols, you'll understand better the people who made and looked at the pictures – and enjoy them all the more. You'll probably find that you already know some of the language of symbols – without knowing you do.

Hunt the symbol

Symbols start with signs. It is convenient to have a sign for a business, for example, that people can recognize. In the past, masons had signs that they put on their stonework. Potters, sculptors, and painters often sign their work with signs. Many artists make interesting shapes out of their initials – the example on the left is of Albrecht Dürer's monogram (**1**). Publishers are often recognized by their logos – like these from Viking (**2**) and Oxford University Press (**3**). Makers of pottery and ceramics usually have a sign they put underneath their wares. These are the signs of the St Ives pottery in England (**4**) and the world-famous Spode pottery (**5**).

But a symbol is something more than a sign. A symbol carries a message that has a meaning which is not just practical (as a logo on a book is). It can touch something deep in us. There are many examples of symbols in this book. You may not have noticed all of them, or not have realized they were symbols.

Look, for example, at the stone carving from the cathedral at Autun on page 56. The three men in bed are wearing crowns. Crowns are symbols of royalty – so you know the men are kings. The pointing figure has wings and a halo – so you know it's an angel. There's a star above them – that means it's night. Because the carving is from a Christian building, we can guess that the carving is telling the story of the the three wise men being warned in a dream by an angel.

In many Christian religious paintings there are different kinds of fruits and flowers, and often different kinds of birds as well. These aren't there just to make the painting look attractive (though they certainly do). Each is a symbol and has a special meaning. Many paintings of the Virgin and Child show Jesus holding a fruit, often an apple or a pomegranate. Now the apple is the fruit that Adam picked from the Tree of Knowledge in the Garden of Eden. It is a symbol for the Fall – the expulsion of Adam and Eve from the Garden of Eden, from Paradise. But the apple in the hand of Christ means that humanity will be saved. In the same way, pomegranates are symbols of eternal life, lilies and white roses are symbols of purity, red roses of martyrdom, and so on.

Other symbols are more complicated. In his salt-cellar on page 74 (detail bottom right), Cellini uses the figure of Neptune, who holds the *salt*, to represent the *salty sea*, and a woman, who holds the *pepper,* to represent the *earth* (pepper is made from a shrub that grows in the earth). Neptune holds a trident (a three-pronged spear) in his hand. The trident, a weapon, is a symbol for the power of Neptune, the god of the sea.

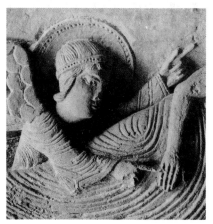

Detail showing an angel, from a carving on the cathedral at Autun. (See page 56.)

But beware!

The trident, as a symbol, has taken on many meanings. The meanings may appear different, but they are related to each other. You remember the trident has three prongs. The number three is very important in religion. So symbols that have three elements keep coming up. The Ancient Greeks and Romans saw the trident as a symbol of lightning, the thunderbolt that comes from the thunderclouds to earth – a symbol of destruction. So the trident came to symbolize Jupiter, the god who ruled the sky. For the Hindus it is the weapon of the god Shiva, the destroyer. For Christians it can mean the Trinity (the number three again) – God the Father, God the Son, and God the Holy Ghost. It is thought that the *fleur-de-lys* (= flower of the lily, in heraldry) also comes from this shape. That is the royal sign of France, again a symbol of power. There is even a national flag, the flag of the island of Barbados, that includes a trident, because as an island Barbados is surrounded by the sea. And you may have heard of the name given to a nuclear submarine – Trident. That certainly is to do with destruction and power.

So when you see a trident in a work of art, you need to know where that particular piece comes from and when it was made, in order to understand its meaning.

Detail of Cellini's salt-cellar, showing the figure of Neptune. (See page 74.)

Sun and circle symbols

Many symbols are based on our experience of the world around us. The most important is the sun, the source of light, warmth, and energy – the source of life itself. It has always been associated with God's blessing.

The sun has been represented in many ways and with different meanings. The halo as used in Christian art is a symbol based on the sun, on light. It represents glory and holiness. When we look at Sassetta's painting on page 34, we know that the two old men must be saints because they have halos. In the Middle Ages, and until about 1450, halos were painted in gold, which made them look even more sun-like.

The Anasazi bowl (centre) from the Southwest of America shows a series of circles and a sun. The design of the sundance lodge of the Siuox people in America (below), used for ritual dances, is also based on the circle.

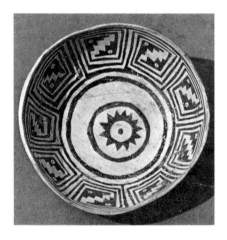

This ceramic plaque was made quite recently in Mexico. It is both a sun and moon symbol.

Halos

It's interesting to keep an eye open for the different ways halos were painted. They were painted as flat discs, whichever way the head inside them was facing, until about 1450. In a crowd of angels, as in the painting on the right, for example, they sometimes overlapped each other, or even partly blocked out an angel's face behind – as if the halos were solid. Quite often a halo had the name of the wearer written on it (a great help in identifying the wearer, so long as you could read it). Christ, as in the mosaic of Christ Pantrocator (Ruler of All) on page 46, was often shown with a halo enclosing a cross.

Sometimes a pope or an emperor, even the donor of a painting, was given a square halo. Later, artists painted the halo still as a solid gold disc, but in perspective, in three dimensions – worn rather like a hat, at an angle. Then they started to paint the halo as a simple ring of light.

After the Renaissance, the halo turned into single rays of light radiating from the head – and was only given to the Holy Family or God. And then artists went off halos and – sadly – stopped painting them. Glory was represented by artists in other ways.

Neapolitanischer Meister, 'The Apocalypse of John', 1340 (detail).

India

Japan

Laos

Uruguay

The sun is such a popular image that it turns up in all sorts of places. The pilgrim badge on page 70 shows St Thomas in the centre of a sun. The horse brass on the same page is another use of a sun symbol – to protect the horse from the evil eye.

The sun and the circle are closely linked as symbols. The circle can become a disc, and the sun appears as a disc. For the Native Americans of the Southwest of America, for example, the circle has a sacred meaning. It represents the unity of life. They built large stone circles, 'medicine wheels', for magical use – perhaps with some of the same sort of beliefs as the builders of Stonehenge. Circles and suns appear carved on rocks, in the patterns on pottery, and in baskets.

There are at least 14 countries in the world – including India and Japan, Uruguay and Laos – that have a sun in their national flag. (Stars are even more popular, with over 50 countries featuring a star or stars on their flag.)

Bird symbols

Birds have also been used as symbols in many religions and cultures. With the Ancient Egyptians, and other ancient peoples, they symbolized the soul, which flies away from the body at death. It can also mean the soul, or the Holy Ghost, in Christian symbolism. Of course, different birds have different meanings. The Christ child is often shown holding a bird, usually a goldfinch. (Goldfinches used to be popular pets with children, because they were so pretty, with their red spot. There is a legend that a goldfinch flew across the path of Christ on his way to be crucified, drew a thorn from Christ's brow, and was splashed with his blood.)

If you look on page 81, you'll find a peacock on a tile. It could just be a beautiful decoration. But since it was made in Syria, and we know that the Syrians in the 15th century used a peacock to represent royalty, perhaps it means royalty here too. In neighbouring Persia (now Iran), the royal throne was called the Peacock Throne. To the Ancient Romans, it was the bird of Juno, the queen of the gods. The Roman empresses took it as their symbol. The Chinese emperors gave a peacock feather as a reward for good service. For the Hindus it was the bird ridden by Subrahmanya, the god of love and war. In the Christian religion the peacock symbolizes immortality and Christ rising from the dead – a bird whose flesh was thought never to decay. In our everyday language it is associated with pride – proud as a peacock, we say.

This metal weathercock used to be on the spire of the church of Cleversulzbach in the South of Germany.

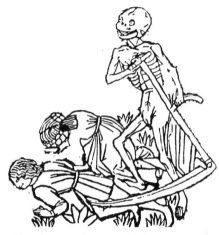

Death was often symbolized by a skeleton figure carrying a scythe for mowing down people, as in this 15th-century woodcut.

In Holbein's painting *The Ambassadors* (page 67), the musical instruments could represent 'the arts', or they might carry a message about death.

Everyday symbols

Symbols don't appear only in religious paintings. In Dutch paintings of the 17th century showing scenes of domestic life, particularly those by Jan Vermeer (1632–1675), many quite ordinary everyday objects have a special meaning. A jug balanced near the edge of a table is meant to remind us that life can end at any moment. Musical instruments may carry the message that earthly things must be left behind when we die. Of course you don't have to understand the coded meaning in order to enjoy the painting. Vermeer's pictures are very easy to enjoy. But if you want to know what the people who lived at Vermeer's time saw in them then you need to know the code.

Signs and their stories

You probably know the spinning firework called the Catherine wheel. But you may not know that it was named after the Christian saint, St Catherine of Alexandria. She is said to have lived about 1,700 years ago. She angered the Roman Emperor Maxentius because she wouldn't marry him and because she wouldn't give up her Christianity. She debated with 50 philosophers – and she won. So the Emperor condemned her to be ground to pieces between four huge wheels. But before this could take place an angel destroyed the monstrous machine – and 4,000 people at the same time.

Catherine has become the patron saint of young girls and students – and also of wheelwrights and spinners. The wheel is what we call her 'attribute'. You can recognize many figures in art by their attributes.

Many of the attributes in European art are to do with the ancient pagan gods or the Christian saints. The Greek goddess Aphrodite (who is the same as the Roman goddess Venus) is shown with a scallop shell, because she was thought to have been born of the sea.

Another very attractive combination of person and attribute which you see in many religious paintings is St Jerome and his lion. The story goes that a lion came to him with a wounded paw. Jerome found that the trouble was a thorn stuck in the lion's paw, and took it out. The lion recovered, became the saint's good friend, and never left him.

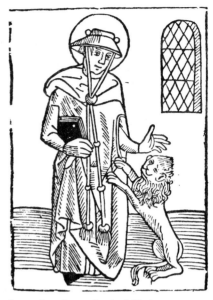

A medieval woodcut of St Jerome and his lion (1483).

Speaking through gesture

Just as symbols have different meanings in different religions and cultures, gestures too can have different meanings. In art they too can give messages to the person looking. Artists can make their figures 'speak' through gestures.

In this book you can find several examples of hand gestures with different meanings. Look at the two hands poking out of the door in N. C. Wyeth's *McKeon's Graft* (*Train Robbery*) (page 14). Raised hands are a kind of symbol for giving in or giving up, for making oneself defenceless, and for despair. The raised arms in Picasso's *Guernica* (pages 38–39) and Goya's *The Third of May 1808* (page 37) give the same message of despair and helplessness.

Even the small chess piece from the Isle of Lewis (page 82) shows a traditional gesture. The bishop is giving a blessing with his raised right hand. This gesture appears in many Christian works of art which feature God the Father, Christ, or the saints.

Other cultures have a quite different range of symbolic hand gestures. The Hindu figure of Nataraja on page 61 shows the front right hand making a traditional reassuring gesture. It means 'Fear not'.

This nativity scene from a 16th-century woodcut shows several message gestures: the king pointing to a star, the kneeling king folding his hands in prayer, and the Christ child making the gesture of blessing.

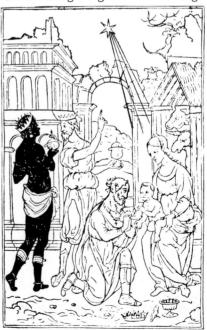

Colourful language

Colours have their own symbolism. Gold represents something precious, and can mean a ruler or a god. Halos were the mark of special beings, and represented glory and holiness, so they were often painted in gold.

There were other colours too that were difficult and expensive to produce. Their message was the same: the object which they coloured was precious. The Romans obtained purple by crushing the shells of rare shellfish. It was a colour reserved for Roman emperors only. Medieval and Renaissance painters liked to use crushed lapis lazuli (an ornamental stone) from which they made a brilliant blue. Artists used this blue for the Madonna's cloak to represent Heaven. They wanted their paintings of her to be regarded as precious objects. The cloak that St Francis threw away (he was a rich young man) in order to become a monk is often painted blue, to stress the riches that he gave up.

In paintings of St Francis and his followers, the Franciscan monks can be recognized by their brown habits and white belt with three knots, reminding the monks of their three vows of poverty, chastity, and obedience. The Dominicans, another preaching religious order, are often shown in paintings in their white tunics, representing purity, and black cloaks, representing their mourning for the death of the Virgin. In some paintings you can find little black-and-white dogs, representing the Dominicans!

Colours have different meanings in different cultures. For example, in India white is the colour of mourning. But in Western countries it is black that is associated with mourning. Many people wear black to funerals, or wear a black tie or a black armband to show their mourning. In contrast, white stands for light, purity and innocence. In Annunciation scenes, you may notice a white lily by the Angel Gabriel – that stands for the purity, of the Virgin. The white of the unicorn also represents innocence and goodness.

Symbol guide

There are hundreds of animals, plants and objects which may have symbolic meanings in works of art. Here are a few of them.

Symbol	Meaning	Culture
bird	the soul	Christian, Ancient Egyptian
bull	strength, fertility	Ancient Greek (Minoan)
	strength	Christian
	strength, fertility; Nandi, the steed of the god Shiva	Hindu
circle/wheel	unity	Native American Indian
	unending circle of birth, life, death	Buddhist
fire	destruction, hell	Christian
	destruction and purification	Hindu
fish	in early Christianity the symbol of the religion	Christian
halo	red halo: energy, life	Buddhist
	glory, holiness	Christian
lily	purity, associated with the Virgin Mary	Christian
serpent, snake	spiritual power, wisdom	African, Hindu
	divine wisdom and power	Ancient Egyptian
	anger	Buddhist
	evil, temptation, sin	Christian, Jewish

▶ Here is another painting full of symbols. It is a watercolour by the 20th-century Swiss artist Paul Klee. He called it Tree of Houses. You can just enjoy it as a picture with lovely colours, interesting shapes and a feeling of fun (like Tomcat's Turf in Chapter 2). But you can also find in it some of the symbols mentioned in this chapter – and others as well.

Paul Klee. 'Tree of Houses', 1918, watercolour and ink on chalk-primed gauze on papers, 23 x 19 cm.

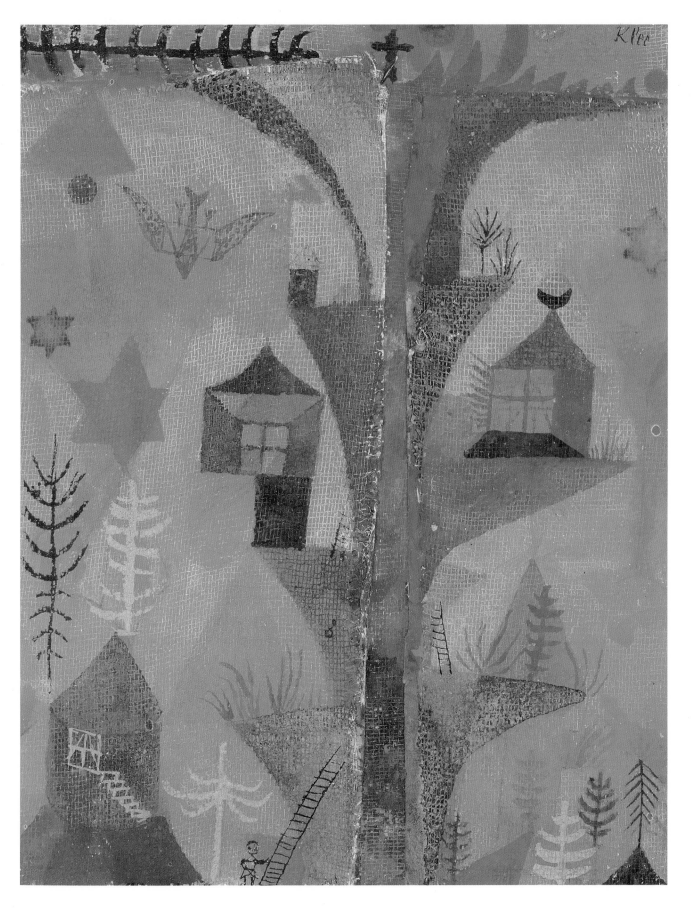

A pathway through art

BC 100 000 15 000 10 000 3000

Ancient Egyptian civilisation

1450 1350

Mantegna develops metal (line) engraving *Illumination of manuscripts*

1550

Jan van Eyck popularizes use of oil paints **The Renaissance in Europe**

1850

Invention of photography *Metropolitan Museum founded 1870*

First World War 1914–1918 **Second World War 1939–1945**

122

In this book you have read about many different kinds of art, some modern, some old. This timeline is to help you sort out the examples of art you have come across in the book, and see them in a rough order of time.

2000 · 1500 · 1000 · 500 · 100

Minoan and Mycenaean civilisation · Ancient Greek civilisation · Roman civilisation

Birth of Christ
AD

1250 · 1150

The Middle Ages in Europe · The Crusades · Battle of Hastings 1066 · Tang Dynasty

1650 · 1750

Invention of the camera obscura · American Revolution 1765–1788

Invention of lithography · *Bewick develops wood engraving* · French Revolution 1789

NOW

First Manned Space Flight 1961 · *Development of computer graphics*

Glossary

Acrylic A synthetic paint invented in the late 1940s. Useful to artists because it dries quicker than oil paint and can be used on nearly all surfaces.

Annunciation Usually used to describe the Angel Gabriel telling the Virgin Mary that she was to give birth to Jesus. Sometimes it is the angel 'announcing' the birth to the shepherds.

Archaeologist Someone who studies the past through old (often buried) buildings and cities, and the objects found in them, such as pots, bones, and coins.

Attribute An object associated with a particular person – often a saint in a work of art – and shown as his or her 'sign'.

Bronze An alloy (mixture) of copper and tin, used for casting figures originally modelled in clay.

Canvas The cloth, usually made of linen but sometimes of cotton, on which most oil paintings since the 16th century have been done. A canvas is stretched taut over a frame and prepared with a primer (first coat) before painting.

Cartoon Originally meant a plan or design for a picture. Nowadays refers to a single drawing (often an amusing caricature) of people or events, or a series of drawings (as in a 'strip cartoon') telling a story.

Ceramics Objects of all sorts made of pottery or porcelain, usually painted and glazed.

Collage A picture or pattern made of pieces of paper, cloth, wood, metal, or any other material, shaped and coloured to fit the artist's design, stuck on to a canvas, card, paper, or wooden background. (Comes from the French word 'coller' = to stick.)

Emblem An object (cross, crescent, shell, sun, etc.) or a figure chosen as a sign to represent an organization, company, occupation, or an individual or family – as in a coat-of-arms, or the shell of St James.

Etching Method of making a print by drawing on a metal plate that is coated with wax, then dipped into acid and inked. Also the name for the print produced by this method.

Folk art The kind of art made traditionally by simple people, often as decoration for things in everyday use.

Fresco A wall-painting made with pigment (colour) mixed with water which has to be completed while the plaster surface of the wall is still wet ('fresh'). Many were painted in Renaissance Italy.

Frieze A band, or strip, of decoration (made of plaster or painted wood, or carved in stone) in or on a building.

Gouache A watercolour paint to which white pigment has been added. Much used by illuminators and painters of miniatures, and popular today as an alternative to pure watercolour.

Hieroglyph In the Ancient Egyptian written language, a figure or object representing what for us would be a word or part of a word.

Icon A painting or image of a saint or sacred figure of the Russian or Greek Orthodox churches. For believers, the icon itself is sacred. Also a small image used in a computer program.

Image In a general sense, everything that you see. A drawing, painting, or model (in any material) of a person or animal, or of a god or goddess.

Impressionists A group of artists (mainly French) of the second half of the 19th century who explored and tried to capture in paint their 'impressions' of outdoor scenes in different conditions of light and weather. They often worked out of doors and were particularly interested in light and colour. The group included Manet, Monet, Renoir, Sisley, Pissarro, Cezanne and Degas.

Line engraving Method of making

a print by engraving an image on a metal plate and inking it and the name of the print produced.

Lithograph Method of making a print from a slab of stone, on which an image has been drawn with a greasy crayon. The stone is wetted and inked. The ink sticks only to the crayon lines. The print is called a lithograph.

Masters: the Great Masters or the Old Masters The phrase used for the most famous European artists (Leonardo da Vinci, Bruegel, Titian, etc.) of the period from the Middle Ages up to about the end of the 17th century.

Medium The material (paint, stone, clay, pencil, etc.) chosen by the artist for a particular work. Also the liquid in which pigment (colour) is mixed.

Middle Ages The period in Europe between about 1000 to about 1400. Also called the medieval period.

Miniature The name given to any tiny painting. In the Middle Ages it referred to illuminations painted on vellum in religious books.

Mosaic A picture or design made by cementing together small pieces of glass, ceramics or stone of different colours. Often used for floors or pavements.

Mural A painting made directly on the wall of a building. A fresco is one kind of mural.

Oils Paint made of pigment (colour) mixed with linseed or poppy oil. First used in the 12th century, but not made popular until the 15th century by Jan van Eyck. From the 16th to the 20th centuries, the most popular medium for artists. Oil paint can be put on in layers and used either thickly or thinly. It dries slowly, allowing the artist to make changes. It is good for painting details and giving an effect of three dimensions.

Palette From the French word for 'little spade'. A small portable tray (usually made of wood), on which an artist sets out and mixes colours. It can also mean the choice of colours in the artist's work.

Perspective Method of showing, on a flat surface (two dimensions), space and distance (a third dimension).

'Pointillism' A method of painting that uses hundreds of dots of different colours, which react together, when you look at them, in a more vivid way than if the colours had been actually mixed together. Invented towards the end of the 19th century by Seurat.

Renaissance A period which began in the 14th century in Italy with a 're-birth' of interest in Ancient Greek and Roman art and thought. ('Renaissance' is French for 're-birth'.) The movement spread through Europe and inspired many great works of art.

Tapestry A woven woollen wall-hanging, usually made with a picture or pattern, particularly popular in the Middle Ages for domestic and religious buildings. Series of tapestries, with a theme or telling a story, were often made to decorate a large room. (The Bayeux Tapestry is really an embroidery, as it is not woven.)

Tempera Paint in which the pigment (colour) is mixed with egg. It was much used by Italian painters of the 14th and 15th centuries, particularly for painting on wooden panels. It dries quickly and gives less depth and variety of colour than oils.

Terracotta Brownish red clay which, when baked, can be used for pottery or sculpture, and then fired. In some hot countries terracotta bricks and tiles are used for building.

Totem A figure, often an animal, adopted by different groups of native Americans as the sign of their people, linking them to their ancestors.

Vellum A fine kind of parchment, made from the skins of calves, lambs, or kids, used for writing (before the introduction of paper), particularly for illuminated manuscripts.

Watercolour Paint in which the pigment (colour) is mixed with gum. When used, it is mixed with water. Since the 18th century it has been particularly popular with landscape artists.

Woodcut and **Wood engraving** Prints made by cutting out an image on a block of wood and inking it (like a linocut).

Photo Credits

Index